# MASTER LIGHTING GUIDE

*for Wedding Photographers*

## Bill Hurter

AMHERST MEDIA, INC. ■ BUFFALO, NY

DEDICATION

The first book I wrote for Amherst Media, *Portrait Photographer's Handbook,* was, by far, the hardest. Every word had to be perfect. Since my job as an editor prevents me from shooting day to day, I wondered how I could ever illustrate such a book with great photographs by great photographers. The answer came in the form of a pep talk from Monte Zucker, who died during the preparation of this, my twentieth book for Amherst Media.

Monte told me that any image he ever made was mine to use if it would help the project. Furthermore, he gave me the formula I needed to entice other world-class photographers to participate in my book projects. With predictable confidence and total self-assurance, he "guaranteed" others would follow and the ones who didn't want to participate I'd be able to count on one hand.

He was, of course, right. It was just one more instance of Monte reaching out to help a colleague succeed. That's what he did and what he was best at. Without the need for personal acclaim, he has helped innumerable people like myself by giving a part of himself to help them succeed.

I dedicate this book to my dear friend and mentor, Monte Zucker, without whom, so many of us would have, perhaps, never found the magic.

Front cover photograph by Mauricio Donelli.
Back cover photograph by Michael Costa.

Published by:
Amherst Media, Inc.
P.O. Box 586
Buffalo, N.Y. 14226
Fax: 716-874-4508
www.AmherstMedia.com

Publisher: Craig Alesse
Senior Editor/Production Manager: Michelle Perkins
Assistant Editor: Barbara A. Lynch-Johnt
Editorial Assistance from: Carey A. Maines and John S. Loder

ISBN-13: 978-1-58428-219-8
Library of Congress Control Number: 2007926867
Printed in Korea.
10 9 8 7 6 5 4 3 2 1

# TABLE OF CONTENTS

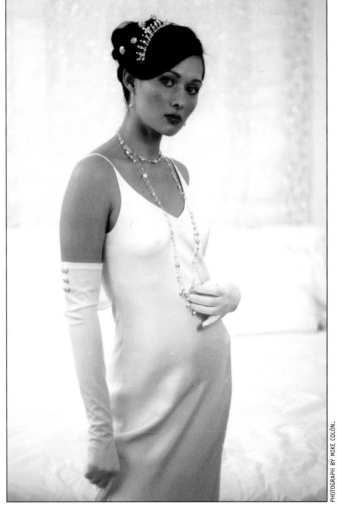

PHOTOGRAPH BY MIKE COLÓN.

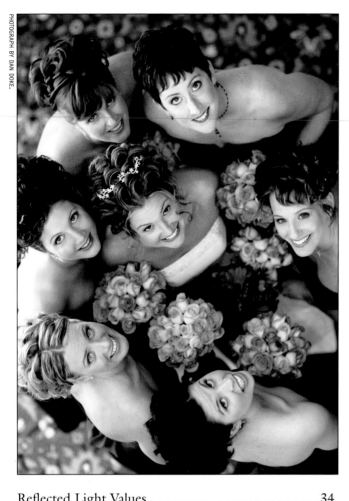

**ABOUT THE AUTHOR**
Bill Hurter started out in photography in 1972 in Washington, DC, where he was a news photographer. He even covered the political scene—including the Watergate hearings. After graduating with a BA in literature from American University in 1972, he completed training at the Brooks Institute of Photography in 1975. Going on to work at *Petersen's PhotoGraphic* magazine, he held practically every job except art director. He has been the owner of his own creative agency, shot stock, and worked assignments (including a year or so with the L.A. Dodgers). He has been directly involved in photography for the last thirty years and has seen the revolution in technology. In 1988, Bill was awarded an honorary Masters of Science degree from the Brooks Institute. He has written more than a dozen instructional books for professional photographers and is currently the editor of *Rangefinder* magazine.

# 1. ALL ABOUT LIGHT

## Simplicity Is Essential

Great lighting is simple; most accomplished photographers will agree that lighting should not call attention

to itself. Even if you are adept at using five lights in harmony, the impact of the subject is still more important than the impact of the lighting. Often, an elegant photograph can actually be made with a single light and reflector—and nothing more. Ultimately, simplicity in your lighting technique creates greater control over how the light shapes the subject and produces subtle effects, rather than exaggerated ones.

That simplicity is an underlying principle of successful lighting is hardly surprising. In nature, on this planet at least, life revolves around a single sun, so there is only one true light source. As a result, we are subconsciously troubled by the disparity we perceive when multiple shadows, created by different light sources, contradict each other. If, on the other hand, there is a single unifying direction to the light, with a single set of corresponding shadows, we are satisfied that it appears normal.

## Light is Energy

Light is energy that travels in waves. Waves are a form of energy that usually move through a medium, like air or water. For example, imagine the ripples in a swimming pool after someone has jumped in. Is it the water that is moving or something else? Actually, the water in the pool stays pretty much stationary. Instead, it is the energy—the wave—caused by the person jumping into the pool that is moving.

Light waves are different than water waves, however, in that they don't require a medium through which to

*FACING PAGE*—Near the edge of a clearing, David Beckstead positioned his bride so that the shade would backlight her, making her veil transparent and dreamlike. Learning to see light is the first step in attaining images that exhibit great lighting technique.

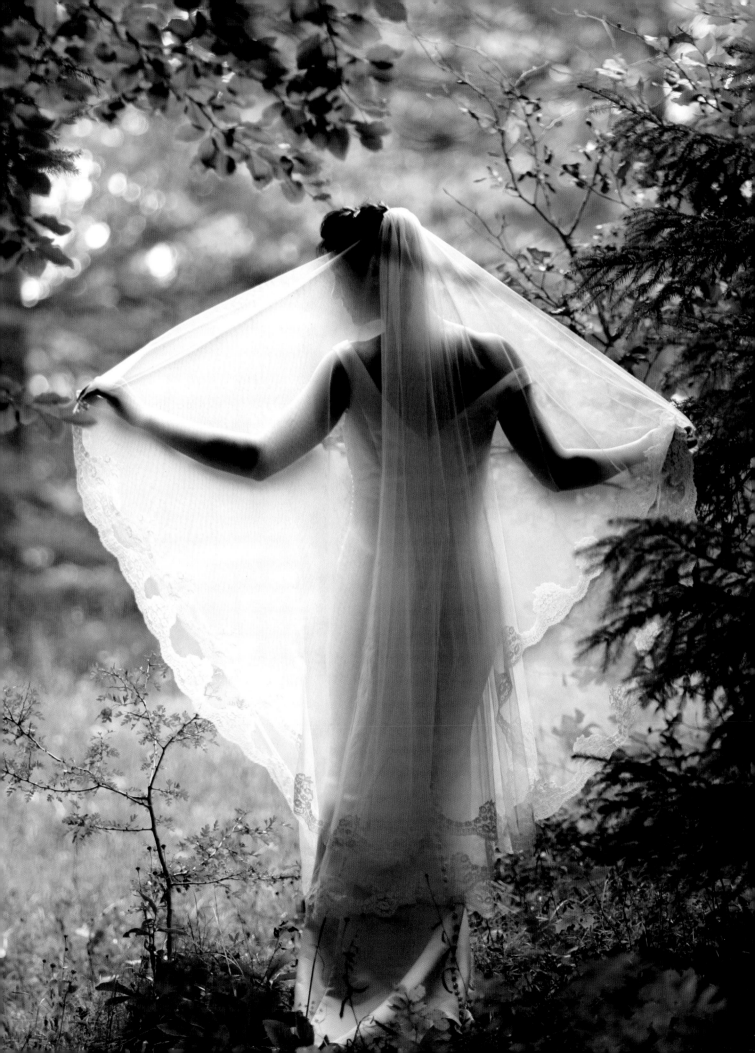

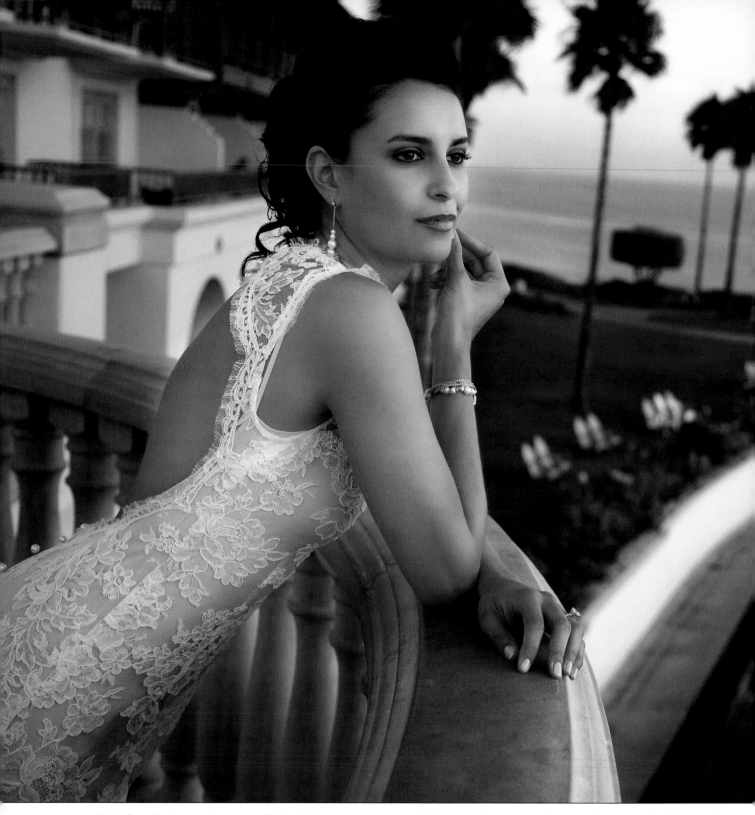

travel. In fact, light travels most efficiently in a vacuum; other elements, like air and water, actually slow light down. Light travels so fast in a vacuum (186,000 miles per second) that it is the fastest known phenomenon in the universe!

Light waves consist of both electric and magnetic energy. Like all forms of electromagnetic energy, the size of a light wave is measured in wavelengths, the distance between two corresponding points on successive waves. The wavelengths of visible light range from 400–700 nanometers (one millionth of a millimeter). The visible spectrum is, however, only a tiny section of the full range of the electromagnetic spectrum, which also includes radio, microwaves, infrared, ultraviolet, X-rays, and gamma

less numbers of photons moving through space as electromagnetic waves. Photons are produced by light sources and reflected off objects. On an atomic level, light works like this: an atom of material has electrons orbiting its nucleus. Different materials have different numbers of electrons orbiting their individual atoms. When atoms are excited or energized, usually by heat, for example, the orbiting electrons actually change to a different orbit and then gradually revert. This process emits photons, which are visible light having a specific wavelength or color. If there are enough photons and the frequency is within the visible spectrum, our eyes perceive the energy as light and we see. Any system that produces light, whether it's a household lamp or a firefly, does it by energizing atoms in some way.

### The Behavior of Light

Unless it is traveling though a vacuum, the medium alters how light behaves. Four different things can happen to light waves when they hit a non-vacuum medium: the waves can be reflected or scattered; they can be absorbed (which usually results in the creation of heat but not light); they can be refracted (bent and passed through the material); or they can be transmitted with no effect. More than one of these results can happen at the same time with the same medium. What's most important to know is that what will happen is predictable. This is the key to understanding how lighting works in a photographic environment.

**Reflection.** One of the characteristics of light that is important to photography has to do with reflected light waves. When light hits a reflective surface at an angle (imagine, for example, sunlight hitting a mirror), the results are totally predictable. The reflected wave will always come off the flat, reflective surface at the equal and opposite angle at which the incoming wave of light struck the surface. In simple terms, the law can be restated as this: the angle of incidence is equal to the angle of reflection. Whether you are trying to eliminate the white glare of wet streets as seen through the viewfinder or to minimize a hot spot on the forehead of your bride, this

rays—types of waves that are differentiated by their unique wavelengths.

### Photons

Without delving into a lengthy description of physics, it is sufficient to say that photons are the raw material of light. When we see visible light, we are witnessing count-

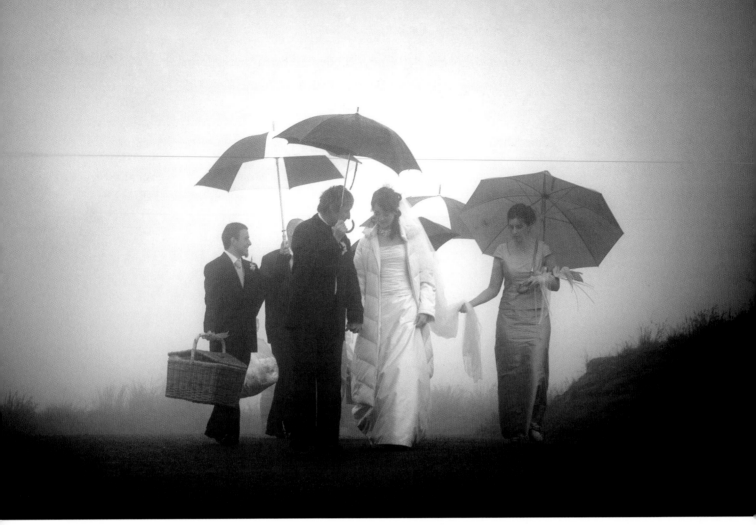

Daylight scattered by passing through thick cloud cover and then again by ground-hugging fog renders subjects with a strangely beautiful transparency. This marvelous shot was done by Jo Gram of Flax Studios in Christchurch, New Zealand, on a very foggy wedding day. Jo made the image with a Canon EOS 1D Mark II and 70–200mm f/2.8 lens. The only effect she introduced was some vignetting in the RAW-file processing.

simple rule will keep you pointed toward the source of the problem.

This rule also has applications in product and commercial photography. For example, when lighting a highly reflective object like silverware, knowing that the angle of incidence equals the angle of reflection tells you that direct illumination will not be the best solution. Instead, you should try to light the surface that will be reflected back onto the shiny object's surface.

*Scattering.* Scattering is reflection, but off a rough surface. Basically, because the surface is uneven, incoming light waves get reflected at many different angles. When a photographer uses a reflector, it is essentially to distort the light in this way, reflecting it unevenly (or, put another way, so that it diffuses the light).

Translucent surfaces, such as the rip-stop nylon used in photographic umbrellas and softboxes, transmit some of the light and scatter some of it. This is why these dif-

fusion-lighting devices are always less intense than raw, undiffused light. Some of the energy of the light waves is being discarded by scattering, and the waves that are transmitted strike the subject at many different angles, which is the reason the light is seen as diffused.

**Refraction.** When light waves move from one medium to another, they may change both speed and direction. Moving from air to glass (to a denser medium), for example, causes light to slow down. Light waves that strike the glass at an angle will also change direction, otherwise known as refraction.

Knowing the degree to which certain glass elements will bend light (known as the refractive index) allows optical engineers to design extremely high-quality lenses, capable of focusing a high-resolution image onto a flat plane (the film or image sensor). In such complicated formulas, now almost exclusively designed by computers, the air surfaces between glass elements are just as impor-

tant to the optical formula of the lens as the glass surfaces and their shapes.

In lighting devices, refraction is used with spotlights and spots with Fresnel lenses. These lenses, which are placed close to the light source, gather and focus the light into a condensed beam that is more intense and useful over a greater distance than an unfocused light of the same intensity.

Spotlights are theatrical in nature, allowing the players on stage to be lit from above or the side by intense but

Daylight streaming in through a window or balcony is soft, yet directional. In this image, Marcus Bell harnessed the soft light of a balcony and the reflected soft light from the white wall against which the bride was leaning. Because the wall's surface was irregular, it scattered the light in all directions. The effect here is like photographing the bride with an ultra-diffused studio softbox.

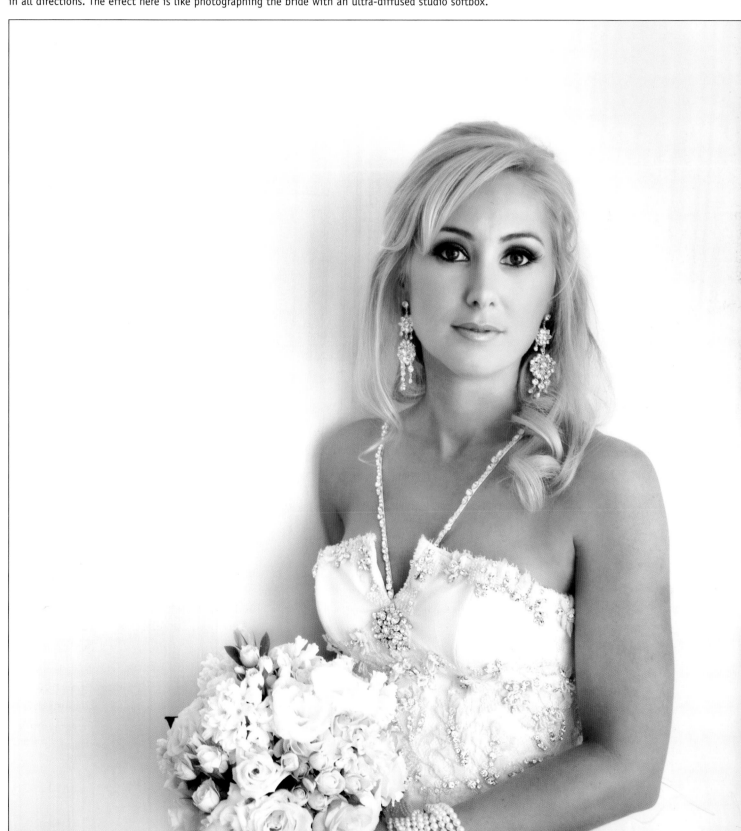

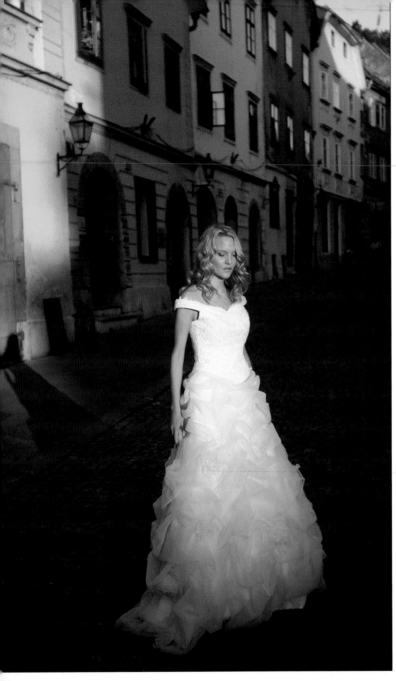

The color of daylight is not white—in fact, it's anything but white, depending on the time of day. Here, David Beckstead used the very low-angle, late-in-the-day light of sunset to capture his bride in hues of red and gold. As the sun nears horizon, it takes on a peculiar quality, almost like a stage spotlight.

ate dense black backgrounds because they absorb all of the light striking their surfaces.

### The Intensity of Light

Another characteristic of light has to do with intensity. Illumination from a light source declines considerably over distance, which is to say that the light grows weaker as the distance increases between the light source and the subject. Light from sources other than the sun (see sidebar) falls off predictably in its intensity.

Put precisely, the Inverse Square Law states that the reduction or increase in illumination on a subject is inversely proportionate to the square of the change in distance from the point source of light to the subject. For example, if you double the distance from the light source to the subject, then the illumination is reduced to one quarter of its original intensity. Conversely, if you halve the distance, the light intensity doubles. This law holds true because, at a greater distance, the same amount of energy is spread over a larger area. Thus any one area will receive less light.

### The Color of Light

When we look at a visible light source, it appears to be colorless or white. However, it is actually a mixture of colors that the eye *perceives* as white. We know this because if you shine "white" light through a prism, you get a rainbow of colors, which are the individual components of the visible spectrum.

Yet, while the human eye perceives most light as white, few light sources are actually neutral in their color. Most have some some color cast, be it the yellow tint

distant lights, but they also have many applications in contemporary photography.

**Absorption.** When light is neither reflected nor transmitted through a medium, it is absorbed. Absorption usually results in the production of heat but not light. Black flock or velvet backgrounds are often used to cre-

---

**THE SUN AND LIGHT INTENSITY**

The Inverse Square Law is true for all light sources but not particularly relevant for the sun. This is because of the minuteness, here on earth, of any potential change in our relative distance from the sun. For all practical purposes, the sun is infinitely bright; it is the only light source that does not fall off appreciably as the distance from the light source increases. Of course, this is not the case with window light, where the light-emitting window, rather than the sun, is the light source. As photographers who have ever had to work with window light know, light falls off the farther you get from the window.

of household incandescent light bulbs, or the green color cast of many fluorescents. The color of light is measured in degrees Kelvin (K) and, therefore, known as the color temperature. The Kelvin scale, like the Fahrenheit and Centigrade scales, is used to measure temperature. It was devised in the 1800s by a British physicist named William Kelvin, who heated a dense block of carbon (also known as a "black body" radiator) until it began to emit light. As more heat was applied, it glowed yellow, and then white, and finally blue. The temperature at which a particular color of light was emitted is now called its color temperature.

**Achieving Color Balance.** It is important for photographers to understand color temperature, because achieving the desired color balance in an image often requires compensating for the color of the light source. This is most commonly accomplished through film selection, filtration, or white balance selection.

Daylight films are balanced to render colors accurately when photographing under light with a color temperature of 5500K. Therefore, they produce the most accurate color during the middle of the day (9AM–3PM). Earlier and later than these hours, the color temperature dips, producing a warmer-toned image in the yellow to

Light can be made diffuse when it passes through a translucent medium, such as rip-stop nylon, the material used in softboxes and umbrellas. Light can also be softened when it bounces off of an irregular surface, such as a stucco wall. The image can also be softened by a soft-focus lens—or, in this case, with a special lens called a Lensbaby, with which you can physically alter the plane of focus. Instead of the focus plane being parallel to the film plane, the lens adjusts laterally and diagonally to shift the focus plane. This wonderful cake was photographed by Cherie Steinberg Coté with a Lensbaby and a Nikon D100 camera. Cherie shifted the lens to the left to produce a very shallow band of focus.

red range. Tungsten films, on the other hand, are balanced for a color temperature of 3200K, considerably warmer than daylight. In the film world, color balance can also be accomplished using color-compensating filters when recording an image under an off-balance light source.

In the digital world, things are much simpler; you merely adjust the white-balance setting of the camera to match the color temperature of the light. Digital SLRs have a variety of white-balance presets, such as daylight, incandescent, and fluorescent. Custom white-balance settings can also be created in-camera by taking a reading off a white card illuminated by the light source in question. When precision color balance is critical, a color-temperature meter can be used to get an exact reading of the light's color temperature in Kelvin degrees. That figure can then be dialed into the white-balance system of many cameras.

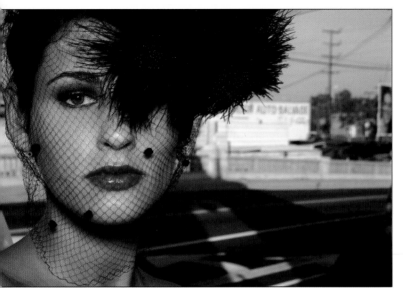

*LEFT*—The color temperature of electronic flash is balanced for midday sunlight, about 5400–5700K. So, using a flash as a key light or a fill light will produce a beautifully color-balanced image during those hours. Here, Cherie Steinberg Coté used an on-camera Nikon flash with its built-in diffuser in place to produce an elegant urban fashion portrait of her bride. *BELOW*—There are no rules about color temperature. Here, Cherie Steinberg Coté, shooting in the afternoon, set the white balance on her Nikon D100 to tungsten in order to produce a myriad of cool tones.

# 2. Lighting Basics

Now that we have covered the basic concepts that control how light behaves, we can begin to explore the ways photographers put this knowledge to work when designing lighting setups. This chapter presents the basic concepts involved in photographic lighting. We'll continue to explore more specialized techniques in subsequent chapters.

## Two Primary Lights

The lights that create virtually all lighting patterns and effects are the key light and the fill light. Even though many different lights may be used in any given photograph, the effect should be the same: that of a key light and a fill light. As noted previously, our human perception is so accustomed to the sun providing our single source of light, that we are happiest when artificial lighting arrays mimic that effect.

**Key Light.** The key light is what creates form, producing the interplay of highlight and shadow. Where you place the key light will determine how the subject is rendered. You can create smoothness on the subject's surface by placing the light near the camera and close to the camera/subject axis; you can emphasize texture by skimming the light across the subject from the side. The key light is the primary tool of the photographic artist, allowing you to paint texture and shadow where you want it by virtue of its placement relative to the subject.

**Fill Light.** The light source that makes the "shadow side" of things visible is called the fill light. The fill light is defined as a secondary light source because it does not create visible shadows. Over the years, photographers have found that the best way to achieve this shadow-filling effect is to place the fill light as close as possible to

**THE THREE-DIMENSIONAL ILLUSION**
The human face is sculpted and round; it is the job of the portrait, fashion, or editorial photographer to reveal these contours. This is done primarily with highlights and shadows. Highlights are areas that are illuminated by a light source; shadows are areas that are not. The interplay of highlight and shadow creates the illusion of roundness and shows form. Just as a sculptor models the clay to create the illusion of depth, so light models the shape of the face to give it depth and dimension. A good photographer, through accurate control of lighting, can reliably create the illusion of a third dimension in the two-dimensional medium of photography.

the camera-subject axis. All lights, no matter where they are or how big, create shadows. But by placing the fill light near the camera, all the shadows that are created by that light are cast behind the subject and are therefore less visible to the camera. Just as the key light defines the lighting, the fill light augments it, controlling the intensity of the shadows created by the key light.

Creating fill light with a reflector has become quite popular in all forms of photography. The reflectors available today are capable of reflecting any percentage of light back on to the subject—from close to 100 percent reflectance with various mirrored or Mylar-covered reflectors, to a small percentage of light with other types. Reflectors can also be adjusted almost infinitely just by finessing the angle at which they are reflecting the light.

## Size of the Light

The size of the light source also affects the results you will produce. Small light sources create tiny shadows

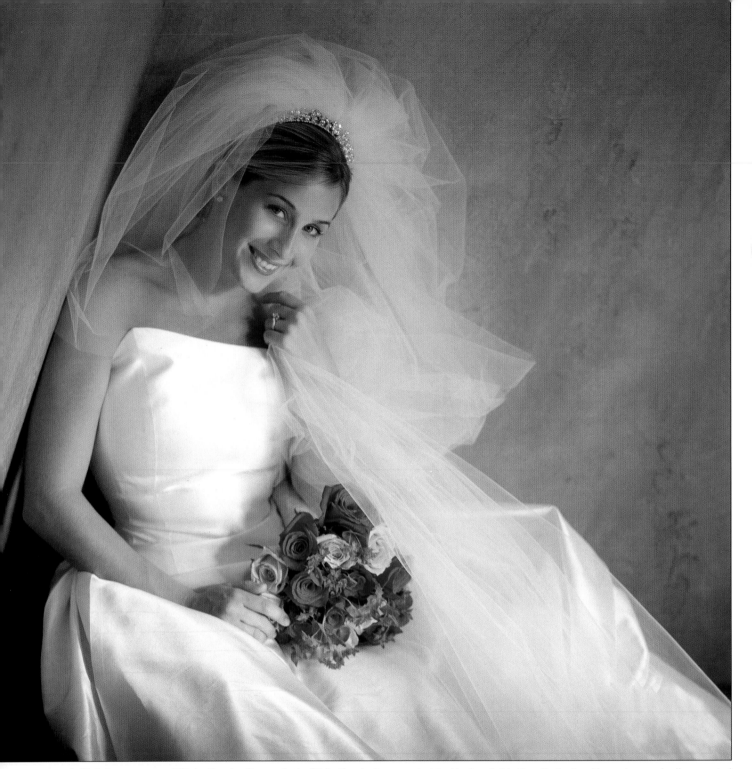

A fill light or source of fill-in illumination works to fill-in the shadows created by the key light. Here Drake Busath used an umbrella-mounted flash as a soft key light and the neutral colored wall provided the fill illumination on her face. If the wall had been colored, the shadows would have taken on that color cast as well.

across a surface; larger light sources, on the other hand, tend to automatically fill in the shadows because of the wraparound quality of the light.

Smaller light sources produce crisper shadows with a sharper transition from highlight to shadow across the subject. If you want texture, which often equates to drama (especially when minimal fill-in illumination is employed in the image) use a small light source.

Larger light sources produce softer shadows with a more even gradation from highlight to shadow. If you want smoothness or softness, use a large light source. The advantage to using larger light sources is that they tend to

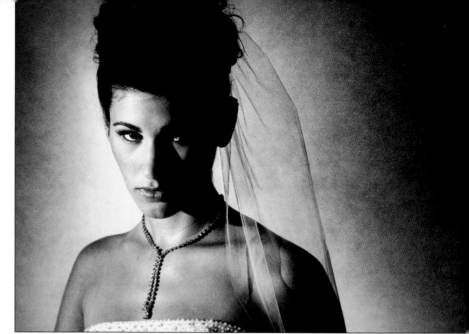

TOP—The job of the key light is to create direction and form and to establish a lighting pattern. A single key light, used above and to the side of the bride, produced a dramatic Rembrandt-style of lighting (note the diamond-shaped highlight on the shadow side of her face). Cherie Steinberg Coté used an undiffused Mole Richardson 1K light held by her assistant to light her bride. BOTTOM—Large light sources will often exist at your wedding venues. For instance, Scott Robert Lim used a bank of windows covered with sheers to create a beautiful wall of light with which to photograph his bride. She was seated no more than six feet from the windows, making the effect much like softbox lighting in the studio.

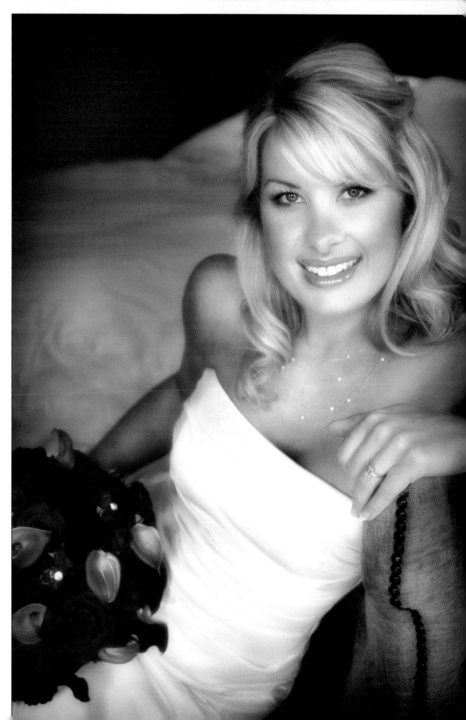

be more forgiving and easier to use. The disadvantage is that they reveal less texture.

The effective size of a light source is determined both by the physical size of the source itself and its distance to the subject. Man-made light sources are physically very small, but they can be made larger by placing them in a light-modifying device like a softbox or umbrella. The light modifier lessens the intensity of the light, but makes it larger and more diffuse in nature. Placing the light source closer to the subject will also make it effectively larger, yielding softer effects. Conversely, distancing the source from the subject will produce crisper, more dramatic lighting.

## Lighting Ratios

A lighting ratio is a numeric expression of the difference in intensity between the shadow and highlight side of the face in portraiture. A ratio of 3:1, for example, means that the highlight side of the face has three units of light falling on it, while the shadow side has only one unit of light falling on it. Ratios are useful because they describe how much local contrast there will be in the portrait. They do not, however, reflect the overall contrast of the scene.

Since lighting ratios tell you the difference in intensity between the key light and the fill light, the ratio is an indication of how much shadow detail you will have in the final portrait. Since the fill light controls the degree to

which the shadows are illuminated, it is important to keep the lighting ratio fairly constant. A desirable ratio indoors or out is 3:1. This ratio guarantees both highlight and shadow detail and is useful in a wide variety of situations.

**Determining Lighting Ratios.** There is considerable debate and confusion over the calculation of lighting ratios. This is principally because you have two systems at

### USING HOT LIGHTS

Using 1000W (1K) hot lights requires some care and safety. A standard 20-amp household circuit provides 2000W of power at maximum capacity, so if two 1K lights are plugged in, you are using the maximum amount of power. If, anywhere in the building, there is another device running on that circuit, you will be drawing more power than is possible and the circuit breaker will engage—meaning you will lose power to the lights and anything else on that circuit. This is why photographers who use hot lights frequently carry lots of long extension cords so that they can power the lights from different outlets and distribute the load evenly over the electrical system.

Another concern is that hot lights are literally hot. The bulbs, lenses, casings, and sometimes even the stands themselves, get quite hot. For that reason, using heavy leather gloves is recommended when working with hot lights. You should also make sure the lights are turned off at the switch before plugging them in. Additionally, you should "sandbag" any tall light stands and all boom stands to to make them more stable.

If you have to change a blown lamp (bulb), turn off the power switch and unplug the light. While wearing your leather gloves, open the face of the light after it has cooled. This will protect you from burns, but it also protects the new bulb you will be inserting. Oils from your fingers can be deposited on the bulb surface if you handle it without gloves, which can cause the glass to explode. This is particularly true for quartz-halogen bulbs. Carefully remove the lamp from its housing and take the new lamp out of its box using the foam padding that comes surrounding the bulb. This is perfect for handling the light and inserting it into the lamp fixture.

The beauty of using hot lights is that you can always see what you're going to get photographically. The dangers, however, are real and should be factored into any lighting setup.

work, one arithmetical and one logarithmic. F-stops are in themselves a ratio between the size of the lens aperture and the focal length of the lens, which is why they are expressed as "f/2.8," for example. The difference between one f-stop and the next full f-stop is either half the light or double the light. For example f/8 lets in twice as much light through a lens as f/11 and half as much light as f/5.6. However, when we talk about lighting ratios, each full stop is equal to two units of light, each half stop is equal to one unit of light, and each quarter stop is equivalent to half a unit of light. This is, by necessity, a suspension of disbelief—but it makes the lighting-ratio system explainable and repeatable.

In lighting of all types, from portraits made in diffused sunlight to editorial portraits made in the studio, the fill light is always calculated as one unit of light, because it strikes both the highlight and shadow sides of the face.

Even if the treatment of the image is soft and ethereal, the lighting still needs to maintain a ratio between highlight and shadow in order to convey dimension and drama. Here, a 3:1 or even a little greater ratio is attained by not using a strong fill source. The lighting ratio helps sculpt the shapes in this very soft image by Mauricio Donelli.

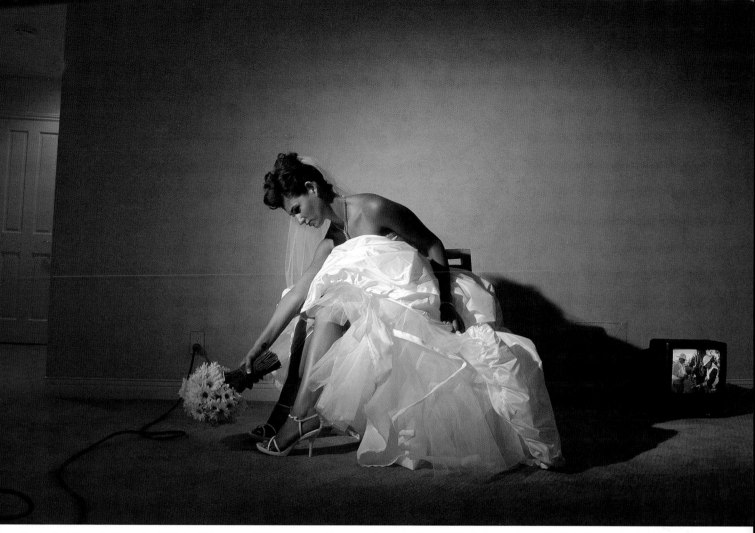

Cherie Steinberg Coté used a 1K Mole Richardson light to create this unusual scene of the bride. As her assistant held the light, Cherie used an 18mm lens to widen the view so that she could include the room as part of the composition. The light cord from the 1K light is intentional and quirky enough to be a pleasant bonus in the composition. Note how well the light falls off at the edges, as seen on the back wall.

The amount of light from the key light, which strikes only the highlight side of the face, is added to that number. For example, imagine you are photographing a small family group and the key light is one stop (two units) greater than the fill light (one unit). The one unit of the fill is added to the two units of the key light, yielding a 3:1 ratio; three units of light fall on the highlight sides of the face, while only one unit falls on the shadow sides.

**Lighting Ratios and Their Unique Personalities.** A 2:1 ratio is the lowest lighting ratio you should employ. It reveals only minimal roundness in the face and is most desirable for high-key effects. High-key portraits are those with low lighting ratios, light tones, and usually a light or white background (see the sidebar on page 22). In a 2:1 lighting ratio, the key and fill-light sources are the same intensity (one unit of light falls on the shadow and highlight sides of the face from the fill light, while one unit of light falls on the highlight side of the

face from the key light—1+1:1=2:1). A 2:1 ratio will widen a narrow face and provide a flat rendering that lacks dimension.

A 3:1 lighting ratio is produced when the key light is one stop greater in intensity than the fill light (one unit of light falls on both sides of the face from the fill light, and two units of light fall on the highlight side of the face from the key light—2+1:1=3:1). This ratio is the most preferred for color and black & white because it will yield an exposure with excellent shadow and highlight detail. It shows good roundness in the face and is ideal for rendering average-shaped faces.

A 4:1 ratio (the key light is 1½ stops greater in intensity than the fill light—2+1+1:1=4:1) is used when the photographer wants a slimming or dramatic effect. In a 4:1 ratio, the shadow side of the face loses its slight glow and the accent of the portrait becomes the highlights. Ratios of 4:1 and higher are considered appropriate low-key

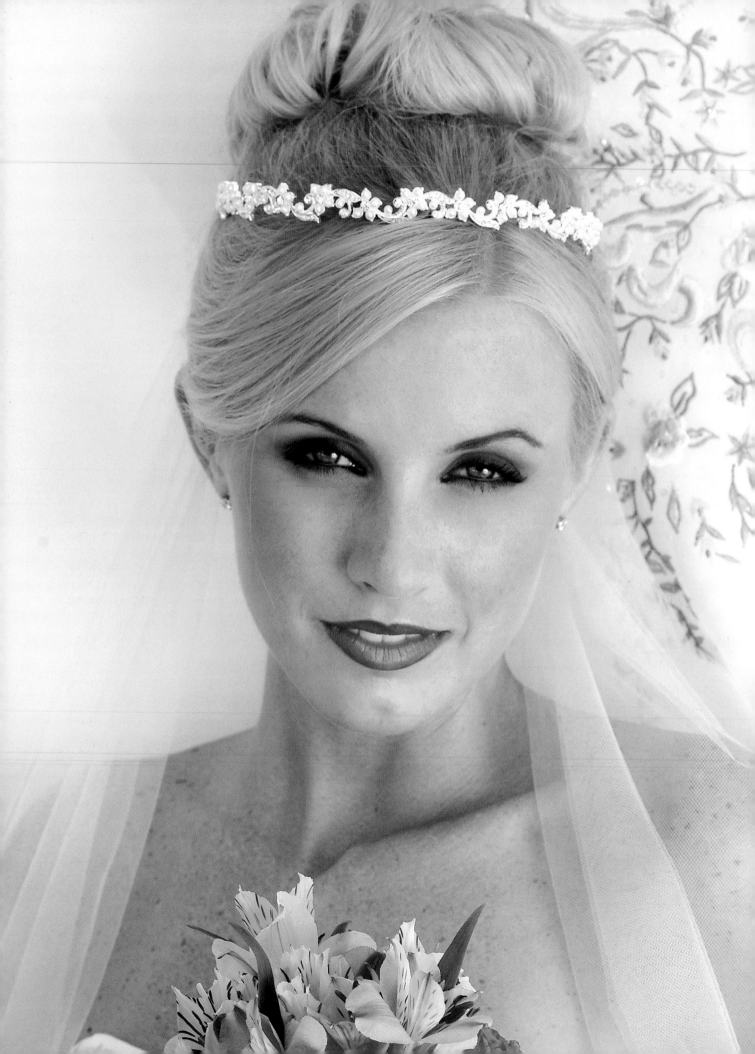

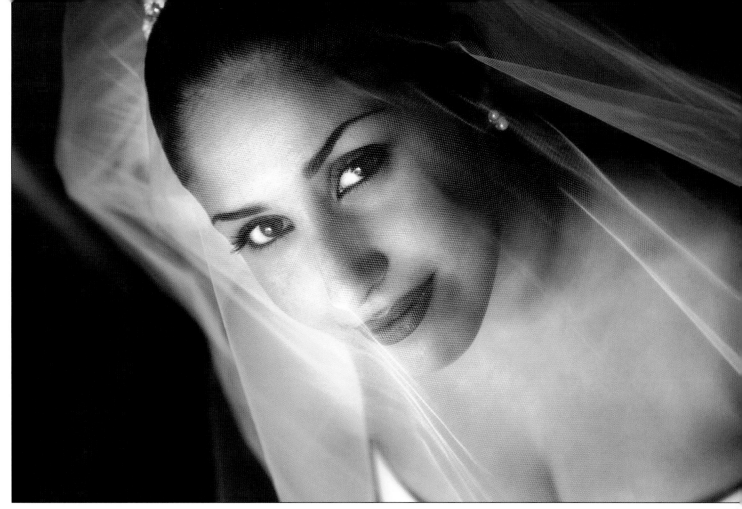

FACING PAGE—A low lighting ratio, such as a 2:1 ratio, still shows form and defines the planes of the face. Here, photographer Rick Ferro used a gold-foil reflector very close to the bride. The reflector, which was held below the bride's face, actually became the main light and the reflected light in and around the scene became the fill light. *ABOVE*—Sometimes, the direction that the subject is turned relative to the position of the light source helps determine the ratio and lighting contrast. Here, a diffused light source was to the bride's right, just below head height. The photographer, Fernando Basurto, had her swivel her head back toward the camera so as to create a distinct shadow side of the face—a much more dramatic pose. Since the light source was diffused, the light wrapped around the shadow or short side of the face, creating a pleasing lighting pattern.

portraits. Low-key portraits are characterized by a higher lighting ratio, dark tones, and usually a dark background.

A 5:1 ratio (the key light is two stops greater than the fill light—2+2+1:1=5:1) is considered almost a high-contrast rendition. It is ideal for adding a dramatic effect to your subject and is often used in character studies. Shadow detail is minimal with ratios of 5:1 and higher. As a result, they are not recommended unless your only concern is highlight detail.

Most seasoned photographers have come to recognize the very subtle differences between lighting ratios, so fractional ratios (produced by reducing or increasing the key light amount in quarter-stop increments) are also used. For instance, a photographer might recognize that with a given face, a 2:1 ratio does not provide enough roundness and a 3:1 ratio produces too dramatic a ren-

dering, thus he or she would strive for something in between—a 2.5:1 ratio.

## Metering

Exposure is critical to producing fine portraits, so it is essential to meter the scene properly. Using the in-camera light meter may not always give you consistent and accurate results. In-camera meters measure reflected light and are designed to suggest an exposure setting that will render subject tones at a value of 18-percent gray. This is rather dark even for a well-suntanned or dark-skinned individual. So, when using the in-camera meter, you should meter off an 18-percent gray card held in front of the subject—one that is large enough to fill most of the frame. (If using a handheld reflected-light meter, do the same thing; take a reading from an 18-percent gray card.)

## HIGH-KEY LIGHTING

There are a number of ways to produce high-key portrait lighting, but all require that you overlight your background by $1^1/_2$ to 2 stops. For instance, if the main subject lighting is set to f/8, the background lights should be set at f/11 to f/16. Sometimes photographers use two undiffused light sources in reflectors at 45-degree angles to the background, feathering the lights (angling them) so that they overlap and spread light evenly across the background. Other setups call for the background lights to be bounced off the ceiling onto the background. In either case, they should be brighter than the frontal

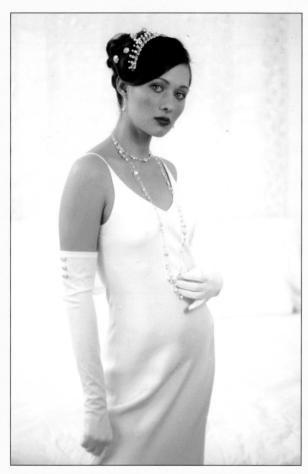

lighting so that the background goes pure white. Because light is being reflected off a white background back toward the lens, it is a good idea to use a lens shade to try to minimize flare, which will often occur in high-key setups.

These two photos show the difference between a high-key treatment with a normal lighting ratio (vertical image) and a true high-key treatment (horizontal). In the vertical image, Mike Colón concentrated on making everything white; he lightened the background and lightened the wedding dress without losing detail, but the light on the bride's face still has a good ratio—almost 3:1. In the horizontal image, the background light, which is overpowering, rim lights every feature of the bride and the detail in the shadow side of the image is a function of Mike expertly handling the exposure of the image.

A better type of meter for portraiture is the handheld incident-light meter. This doesn't measure the reflectance of the subject; instead, it measures the amount of light falling on the scene. To use this type of meter, simply stand where you want your subject to be, point the hemisphere of the meter directly at the camera lens, and take a reading. Be sure that the meter is held in exactly the same light that your subject will be in. This type of meter yields extremely consistent results and is less likely to be influenced by highly reflective or light-absorbing surfaces. (A good rule of thumb when setting your lights is to point the meter at the light source if only one light source is being measured; if multiple lights are being metered, point the dome of the meter at the camera lens.)

A handheld incident flashmeter is useful for determining lighting ratios—and crucial when mixing flash and daylight. Flashmeters are also invaluable when using multiple strobes and when trying to determine the overall evenness of lighting in a large-size room. Flashmeters are ambient incident-light meters, meaning that they measure the light falling on them and not light reflected from a source or object, as the in-camera meter does.

*FACING PAGE*—In a fashion shoot for *Ceremony* magazine, Mike Colón used a diffused strobe at sunset. Carefully controlling the level of ambient light, he metered his strobe, then adjusted the shutter speed to create the desired level of background exposure. Shots like these, with fleeting daylight, are almost impossible without the help of a digital flashmeter.

# 3. CONTROLLING STUDIO LIGHTS IN THE FIELD

While there are many types of high-intensity lights designed for photography, most professional photographers choose to work with strobes—electronic studio flashes. Strobes have several advantages over other types of lighting: they are cool working, portable, and

Bruce Dorn created this stunning bridal portrait with a Westcott Spiderlite TD5 equipped with five 5500K daylight fluorescent coils in a 36x48-inch softbox. Even though the Spiderlite's fluorescents are on the warm side, Dorn decided to warm the light further by adding a $1/2$ CTO gel filter to the softbox, warming the output by about 1000K. With the light placed slightly behind his bride, Dorn asked his assistant to position a Westcott Natural Reflector close to the bride to kick in some much-needed light for the overall exposure.

run on household current. They also use self-contained modeling lights that are usually variable (dimmable) quartz-halogen bulbs that mimic the light of the surrounding flash tube, helping you to visually gauge the effect you are creating before shooting.

## Studio Strobe Systems

Studio strobes come in two types: monolights and power-pack kits. In either case, the strobes must be triggered by the camera to fire at the instant the shutter curtain is open. This is most simply accomplished with a sync cord that runs from the camera's PC connection to one of the monolights or to the power pack, depending on the system you choose.

**Monolights.** Monolights are self-contained. These units contain light triggers to fire the strobe when they sense the light of another strobe, so they can be used very far apart and are ideal for location lighting or large rooms. Simply plug one into a household AC socket and you're ready to go.

**Power-Pack Systems.** Power-pack systems accept multiple strobe heads—up to four individual strobe heads can usually be plugged into a single, moderately priced power pack. This type of system is most often used in studios, since you cannot move the lights more than about twenty-five feet from the power pack. Power-pack outlets are usually divided into two channels with variable settings, providing symmetrical or asymmetrical output distributed between one, two, three, or four flash heads.

## Types of Studio Strobes and Accessories

Here are some variations in strobes and the accessories used to modify the quality and quantity of light output.

**Barebulb.** When the reflector is removed from the flash head, you have a barebulb light source. The light scatters in every direction. Removing the reflector has advantages if you have to place a light in a confined area. Some photographers use barebulb flash as a background light for a portrait setting, positioning the light on a small floor stand directly behind the subject. Barebulb heads are used inside softboxes, light boxes, and strip lights for the maximum light spray inside the diffusing device.

**Barn Doors.** These are black, metallic, adjustable flaps that can be opened or closed to control the width of the beam of the light. Barn doors ensure that you light only the parts of the scene you want lit. They also keep stray light off the camera lens, helping to prevent lens flare.

**Diffusers.** A diffuser is nothing more than frosted plastic or acetate in a frame or screen that mounts to the lamp's metal reflector, usually on the perimeter of the reflector. A diffuser turns a parabolic-equipped light into a flood light with a broader, more diffused light pattern. When using a diffuser over a light, make sure there is sufficient room between the diffuser and the reflector to allow heat to escape (this is more important with hot lights than with strobes). The light should also have barn doors attached. As with all lights, they can be "feathered" by aiming the core of light away from the subject and just using the edge of the beam of light.

**Flats.** Flats are large, white opaque reflectors that are portable (usually on rollers or casters). Once they are wheeled into position, lights can be bounced into them like a temporary wall.

**Gobos.** Sometimes, because of the nature of the lighting, it is difficult to keep unflattering light off of certain parts of the portrait. For instance, hands that receive too much light can gain too much dominance in the photo-

### DON BLAIR'S BAREBULB LIGHT

One piece of equipment Don Blair used often in his quest for natural and pleasing lighting was the tried-and-true barebulb electronic flash, a tool that is versatile and multifaceted. He said, "We can create simple, effective lighting using the barebulb, but it seems to be a technique that photographers overlook. I have made the barebulb one of the most important tools in my lighting arsenal. It can be used on location as a main light, an accent light, a fill light or simply as an overall supplementary light to brighten the entire scene. Used correctly, the barebulb gives a very natural look to the photograph and it adds specularity and punch—an extra burst of light that could be described as an explosion of light—that can turn a nice picture into a beautiful portrait."

The effect of a barebulb flash in this elegant bridal portrait is more than noticeable. Don Blair used the flash as a fill light beneath and to the right of the camera. The purpose of using the light as an auxiliary fill light was to add sparkle and "oomph" to the shadow side of the face, which it does to perfection.

graph. A good solution is to use a device called a gobo or flag, which is a light blocking card (usually black) that can be attached to a boom-type light stand or C stand, or held by an assistant. When placed in the path of a diffused light source, the light will wrap around the flag, creating a very subtle light-blocking effect. The less diffused the light source, the more pronounced the effect of the gobo will be.

This is a classic and award-winning shot by the Australian master wedding photographer, Yervant. It was done not using studio strobes, but an overhead "can" light in an underground parking garage. Yervant, short on time, realized he had not done any formal bridal portraits on the day. So he coaxed the bride down to the parking garage, where he had her throw her head back in laughter so that the light would fill her face instead of obscuring her eyes in shadow. This shot illustrates not only the resourcefulness of the wedding photographer on location, but also the ability to see light and recognize a prime location.

In the field, these panels are often used to block overhead light in situations where no natural obstruction exists. This minimizes darkness under the eyes and, in effect, lowers the angle of the key light so that it is more of a sidelight. Gobos are also used to create a shadow when the the key-light source is too large, with no natural obstruction to one side or the other of the subject.

**Grid Spots.** Grid spots are honeycomb metal grids that snap onto the perimeter of the light housing. They come usually in 10-, 30-, and 45-degree versions, with the 10-degree grid providing the narrowest beam of light. Each comb in the honeycomb grid prevents the light from spreading out. Grid spots produce a narrow core of light with a diffused edge that falls off quickly to black. Because the light is collimated, there is very little spill with a grid spot. Grid spots provide a great amount of control because they allow you to place light in a specific and relatively small area. This makes them ideal for portraits where a dramatic one-light effect is desired. The light naturally feathers at its edge providing a beautiful transition from highlight to shadow. If the grid spot is the only frontal light used in a studio setting, the light will fall off to black, for a very dramatic effect.

**Mirrors.** Mirrors are used to bounce light into a shadow area or to provide a reflected key light. Mirrors reflect a high percentage of the light that strikes them, so they can be used outdoors to channel backlight into a key light. On a tabletop setup, small mirrors the size of matchbooks are sometimes used to kick light into a hard-to-light area.

**Reflectors.** A reflector is a surface used to bounce light onto the shadow areas of a subject. A variety of reflectors are available commercially, including the kind that are collapsible and store in a small pouch. The surface of reflectors can be white, translucent, silver foil, black (for subtractive lighting effects), or gold foil. The silver- and gold-foil surfaces provide more light than matte white or translucent surfaces. Gold-surfaced reflectors are also ideal for shade, where a warm-tone fill is desirable.

When using a reflector, place it slightly in front of the subject's face, being careful not to have the reflector beside the face, where it may resemble a secondary light source coming from the opposite direction of the key light. Properly placed, the reflector picks up some of the key light and wraps it around onto the shadow side of the face, opening up detail even in the deepest shadows.

**Parabolic Reflectors.** Photographic lights accept different sizes of parabolic reflectors (also called pans because of their shape), which mount to the perimeter of the light housing. Without a reflector, the bare bulb would scatter light everywhere, making it less efficient and difficult to control. In the old days, everything was

lit with polished-silver metal parabolics because of the light intensity that was needed to capture an image on very slow film with very slow lenses. This was obviously before strobes. The advantage of learning to light with parabolics is that you had to see and control light more efficiently than with diffused sources, which are much more forgiving.

Parabolics create a light pattern that is brighter in the center with light gradually falling off in intensity toward the edges. The penumbra is the soft edge of the circular light pattern and is the area of primary concern to the portrait photographer. The center of the light pattern, the umbra, is hot and unforgiving and produces highlights without detail on the face. Feathering the light (adjusting the light to use the soft edge of the light pattern) will help achieve even illumination across the facial plane with soft specular highlights.

Today, some pan reflectors are polished, while some use a brushed matte surface to diffuse the beam of light. Some have facets that gather and focus the light. Photographers rarely use undiffused pan reflectors any more, but for beautiful specular light with a highly functional feathered edge, nothing beats the polished pan reflectors.

The smallest of these reflectors is usually the five-inch standard reflector, which is good for protecting the flash tube and modeling light from damage. It also makes the light more compact for traveling.

With the wide-angle reflector attached, light is reflected out in a wide pattern. This reflector is often used to focus the light onto the surface of an umbrella and to shoot into flats or scrims. The wider spread of light also makes this modifier ideal for bouncing light off ceilings and walls—it is controllable and efficient, with minimal light loss. The resulting bounced light is a very soft, and

Portable LiteDiscs from Photoflex are flexible reflectors that fold up into a compact shape for transport. They come in a variety of surfaces and sizes and some are reversible. The in-use shots show the effect of gold-foiled LiteDisc used close to the subject.

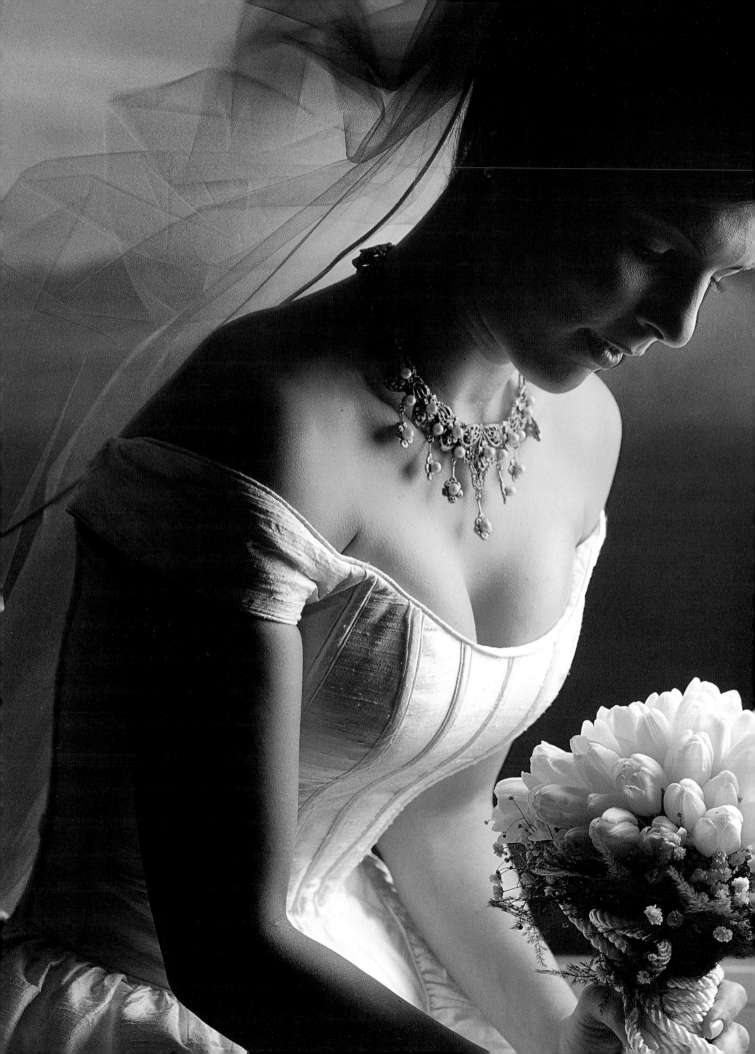

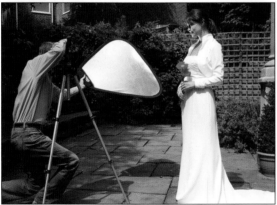

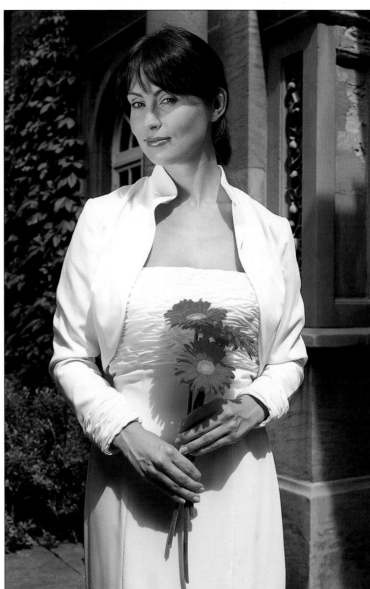

*FACING PAGE*—Mauricio Donelli created this edgy bridal formal using a softbox as the backlight. He often takes studio strobes on location to create elegant lighting in natural surroundings. The exposure was balanced for the ebbing daylight to create a dramatic portrait at dusk. No fill was used to keep the lighting dramatic. *ABOVE*—A Lastolite handheld Tri-Grip reflector from Bogen Imaging with before and after images.

the quality can be controlled by changing the distance from the flash head to the reflector, wall, or ceiling.

**Scrims.** Scrims are translucent diffusers. Light is directed through the material of the scrim to diffuse the light. In the movie business, huge scrims are suspended like sails on adjustable flats or frames and positioned between the sun (or a bank of lights) and the actors, diffusing the light over the entire area. A scrim works the same way a diffuser in a softbox works, scattering the light that shines through it.

Legendary photographer Monte Zucker perfected a system of using large scrims—3x6 feet and larger. With the sun as a backlight, he had two assistants hold the translucent light panel above and behind the subject so that the backlighting was diffused. He paired this with a reflector placed close in front of the subject to bounce the diffused backlight onto the subject or subjects. The effect is very much like an oversized softbox used close to the subject for shadowless lighting.

Scrims can also be used in window frames for softening sunlight that enters the windows. Tucked inside the window frame, the scrim is invisible from the camera.

**Snoots.** Snoots are attachments that snap to the light housing and resemble a top hat. Snoots narrow the beam

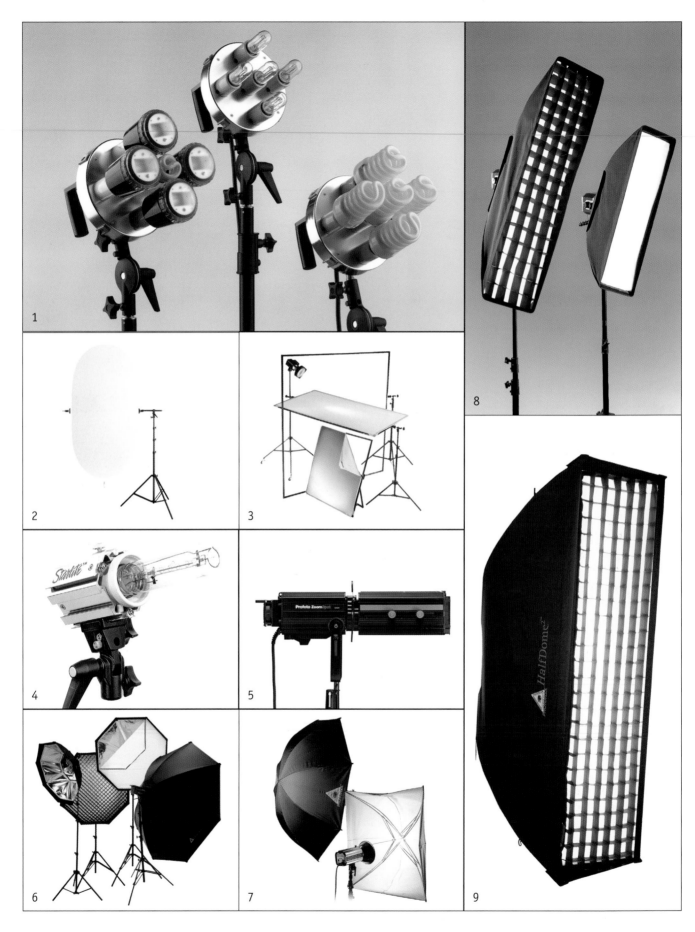

10

11    12

13    14

**1**—The Westcott Spiderlite TD5 can be con-figured with five coiled fluorescent tubes, four AC-powered strobes with a fluorescent modeling light in the center, or five tungsten bulbs—all in a compact housing that fits in a 24x32-inch softbox. **2**—LiteDiscs come in round and oval shapes. **3**—Lite Panels from Photoflex are translucent and reflective flex-ible panels that can be combined to create any kind of lighting on a set or on location. **4**—The Photoflex Starlite QL is a 3200K tungsten light for softbox applications. It is cool-working and bright. **5**—The Profoto ZoomSpot is a focusable, light-shaping tool designed to create stage-lighting effects, accent lighting across huge distances, or for back-ground projection. The zoom lens provides an adjustable light spread from 15 to 35 degrees. **6**—The Photoflex OctoDome 3 is an eight-sided softbox that can be fitted with a variety of internal reflective materials and baffles to soften the center of the light. Grids can also be attached. **7**—Umbrellas come in a variety of sizes and shapes. Some have opaque backing for maximum light output; others are translucent for shoot-through effects. **8**—The Westcott Stripbank is ideal for hair lights or soft-edged backlights. The Stripbank can be adapted with a grid baffle. **9**—Here is a Photoflex Half Dome with a grid for better directional control of light. This type of narrow softbox is often used as a diffused hair light or kicker in portrait work. **10**—The Profoto StickLight is a small and handy lamp head ideally suited for a multitude of lighting effects, including placing the unit inside subjects like furniture, automobiles, and interiors. It can also be used as a hand-held light-painting tool. **11**—The Profoto MultiSpot offers a small, directional light source with a direct, sharply focused beam of light. **12**—The Profoto FresnelSpot is a classically sized spotlight that creates "movie light" with sharp, deep shadows and highly sat-urated color. This FresnelSpot offers lighting adjustments between 10 and 50 degrees. **13**—The Profoto D4 is a 4800Ws power pack that ac-cepts four flash heads, which can be used asymmetrically or symmet-rically. **14**—The Profoto Pro-B2 is a battery-powered flash system designed for location photography. An internal 32-channel radio re-ceiver is built in for remote operation.

of light into a very thin core. They are ideal for small edge lights used from behind the subject.

**Softboxes.** A softbox is like a tent housing for one or more undiffused strobe heads. Often, fiberglass rods pro-vide the rigid support of the softbox housing. The frontal surface is translucent nylon, usually a double thickness. The sides are black on the outside and white on the inside to gather and diffuse more light. Softboxes come in many sizes and shapes. Although most are square or rectangu-lar, there are also a few round or octagonal ones. The size ranges from 12-inches square all the way up to 5x7 feet. Softboxes are ideal for putting a lot of diffused light in a controlled area, and provide more precise control over the light than umbrellas, which lose much of their light intensity to scatter. Some softboxes accept multiple strobe heads for additional lighting power and intensity.

*Strip Light.* A strip light is a long skinny softbox. Strip lights are used as background and hair lights in portrai-ture, as well as edge lights for contouring in tabletop pho-tography. Sometimes they can be used as odd-shaped key lights, although they are usually so small that they can be tricky to use for this purpose.

**Spotlights.** A spotlight (or "spot") is a hard-edged light source. Usually, it is a small light with a Fresnel lens attached. The Fresnel is a glass filter that focuses the spotlight, making the beam stay condensed over a longer distance. Barn doors are usually affixed to spots so that they don't spray light all over the set. Spots are often used to light a selected area of the scene, like a corner of the room or a portion of a seamless background. They are usually set to an output less than the key light or fill (although at times they may be used as a key light). Spots produce a distinct shadow edge, giving more shape to the subject's features than lower-contrast, diffused light sources. Although originally a hot light, various strobe manufacturers have introduced strobe versions of Fresnel spots.

**Umbrellas.** Umbrellas, while not as popular as they once were, are still useful for spreading soft light over large areas. They produce a rounded catchlight in the eyes of portrait subjects and, when used close to the subject, provide an almost shadowless light that shows great roundness in the human face. Umbrellas are usually used with a wide-angle reflector on the flash head, enabling you to better focus the beam of light for optimal effect (see sidebar below). This means sliding the umbrella back and forth until the light covers the entire umbrella surface without spill.

Photographic umbrellas are either white or silvered and used fairly close to the subject to produce a soft directional light. A silver-lined umbrella produces a more specular, direct light than a matte-white umbrella. When using lights of equal intensity, a silver-lined umbrella can be used as a key light because of its increased intensity and directness. It will also produce wonderful specular highlights in the overall highlight areas of the face. A matte-white umbrella can then be used as a fill or secondary light source.

Some photographers use a translucent umbrella in the reverse position, turning it around so that the light shines through it and onto the subject. This gives a softer, more directional light than when the light is turned away from the subject and aimed into the umbrella (bouncing it out of the umbrella and back onto the subject). Of course,

### FOCUSING UMBRELLAS

Umbrellas fit inside a tubular housing in most studio electronic flash units. The umbrella slides toward and away from the flash head and is anchored with a set-screw or similar device. The reason the umbrella-to-light-source distance is variable is that there is a set distance at which the optimal amount of strobe light hits the umbrella. This occurs when the light strikes the full surface. If the umbrella is too close to the strobe, much of the beam of light will be focused past the umbrella surface and go to waste. If the light is too far from the umbrella surface, the perimeter of the beam of light will extend past the umbrella's surface, again wasting valuable light output. When setting up, use the modeling light of the strobe to focus the distance correctly, so the outer edges of the light core strike the outer edges of the umbrella.

Charles Maring created diffuse specular highlights (along the bridge of the bride's nose and on her forehead), diffused highlights (on the frontal planes of her face), and soft shadow values with a diffused shadow transfer edge (the transition from highlight to shadow). It is a lighting masterpiece.

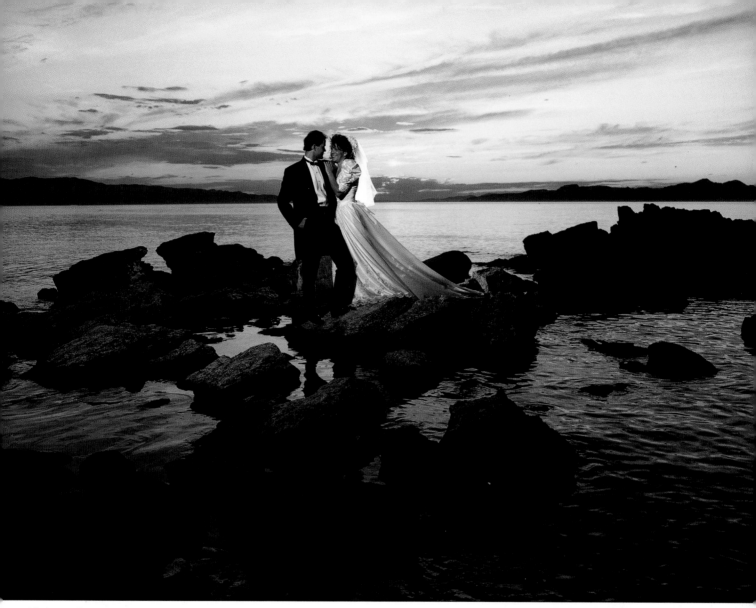

This is a Bill Duncan image taken on the shores of the Great Salt Lake. Since the sun was setting and there were no modeling lights on the flash, everything had to be just right. The separation light was behind the bride and aimed at her dress. Bill used non-automatic flash units and a radio remote to fire them. The main fill light was a Metz 60CT4 positioned next to the camera and fourteen feet high. According to Duncan, "You cannot see any of the light effects since you do not have a modeling light on either unit, so you just have to know where and what the flash units will do." He likes the effect of a parabolic reflector, in this case a five-inch round dish on the backlight. The main light is set up high since, as he says, "You do not want the main light to come in at a low angle, which would make the lighting look phony or totally additive." Bill used a spot meter to measure the light, pointing the meter just to the side of the sun, never aiming the meter directly at the sun.

with a silver-lined umbrella, you can't shine the light through it, because the silvered material is opaque. There are many varieties of shoot-through umbrellas available commercially and they act very much like softboxes.

## The Perfect Fill

In a perfect world, fill light would be shadowless, large, and even—encompassing every part of the subject from top to bottom and left to right. The fill light would be soft and forgiving and variable. And it would complement any type of key lighting introduced.

Well, there is such a system and I have seen it used by a number of portrait, fashion, and commercial photographers. The system involves using strobe heads in narrow-angle reflectors bounced into a white or gray wall or flat behind the camera. Usually, one light is used to either side of the camera, and one is placed over the camera and aimed high off the flat or at the wall–ceiling intersection. (*Note:* the walls or flats must be white or neutral for this method to be an effective fill light. Also note that the lights are close to the wall and the "set" where the subject is positioned. Proximity will keep the light soft.)

Marcus Bell often takes an umbrella and strobe on location to his weddings for just such situations as this. The umbrella light is soft and directional. Fill light came from the tungsten light within the church and provided a golden fill to the shadow side of the face, while the strobe and umbrella were daylight balanced. Notice the just-visible sculpture in the background to the bride's left.

The lights are balanced to produce the same output across the subject. The key light, which may be from the side or above, will be equal to or more intense than the fill source, creating a ratio between the fill and key lights. If positioned to strike the subject from the side, the key light will introduce texture into the subject.

A variation on this setup is to rig a large white flat over and behind the camera. Two or three strobe heads can then be bounced into the flat for the same effect as described above. Some of the light is bounced off the flat and onto the ceiling, providing a very large envelope of soft light.

### Reflected Light Values

There are three distinct values of reflected light: specular highlights, diffused highlights, and shadow values. These are sometimes referred to collectively as lighting contrast.

**Specular Highlights.** Specular values refer to highlights that are pure paper-base white and have no image detail. Specular highlights act like mirrors of the light source. Specular highlights exist within diffused highlight areas, adding brilliance and depth to the highlight.

**Diffused Highlights.** Diffused highlight values are those bright areas with image detail.

**Shadow Values.** Shadow values are areas that are not illuminated or partially illuminated.

Small focused light sources have higher specular quality because the light is concentrated in a small area. Larger light sources like softboxes and umbrellas have higher diffused highlight values because the light is distributed over a larger area, and it is scattered.

**Shadow Edge.** The shadow edge, the region where the diffused highlight meets the shadow value, also differs between these two types of light sources. Depending on the size of the light, the distance of the light from the subject, and the level of ambient or fill light, the transition can be gradual or dramatic. With a small light, the transfer edge tends to be more abrupt (depending, again, on the level of ambient light). With larger light sources, the transfer edge is typically more gradual.

Portrait lighting imitates natural lighting. It is a one-light look. In other words, even though numerous lights may be used, one light must dominate and establish a pattern of shadows and highlights on the face. All other lights are secondary to the key light and modify it. The placement of the key light is what determines the lighting pattern in studio portraiture.

The shape of the subject's face usually determines the basic lighting pattern that should be used. You can widen a narrow face, narrow a wide face, hide poor skin, and disguise unflattering facial features, such as a large nose, all by thoughtful placement of your key light.

## Basic Portrait Lights

These lighting techniques can be done with very basic equipment. A full set of four lights with stands and parabolic reflectors can be purchased quite reasonably. The lights can be electronic flash units or they may be incandescent lights. The latter is preferred in learning situations, because what you see is exactly what you get. With strobes, a secondary modeling light is used within the lamp housing to approximate the effect of the flash.

**Key and Fill Lights.** The key and fill lights should be high-intensity bulbs seated in parabolic reflectors. Usually 250–500W is sufficient for a small camera room. If using electronic flash, 200–400Ws per head is a good power rating for portraiture. Reflectors should be silver-coated on the inside to reflect the maximum amount of light. If using diffusion, such as umbrellas or softboxes, the entire light assembly should be supported on sturdy stands or boom arms to prevent them from tipping over.

The key light, if undiffused, should have barn doors affixed. Barn doors ensure that you light only the parts of

the portrait you want lit. They also keep stray light off the camera lens, which can prevent lens flare.

In strict traditional terms, one might say this lighting lacks drama. However, many brides cherish this soft look with a very editorial feel. In this image by Becker, the lighting ratio is about as close to 1:1 as you can get—but notice the exquisite detail in the gown. The only near-black tones are in the vignette, which the photographer added in Photoshop.

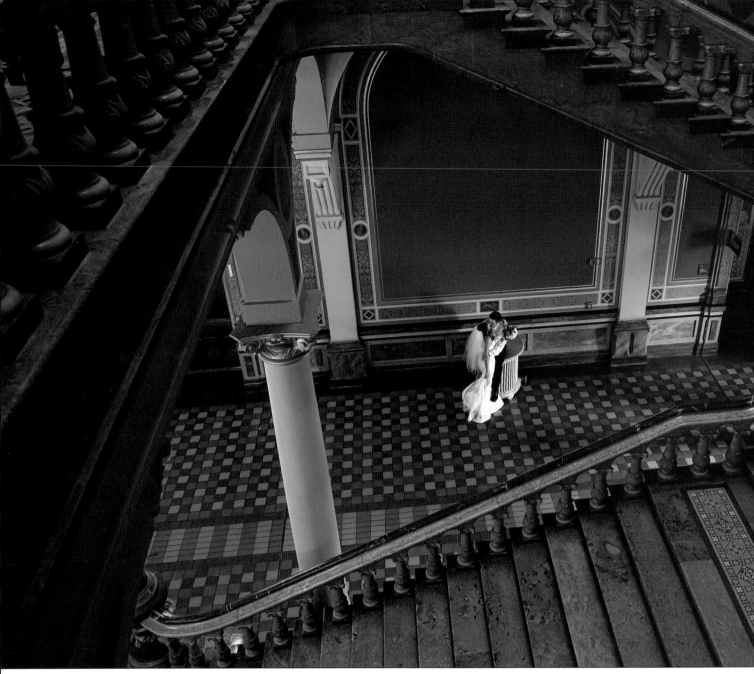

The fill light should be equipped with a diffuser. Like the key, it should have barn doors attached. If using a diffused fill-light source, such as an umbrella, be sure that you are not "spilling" light into unwanted areas of the scene, such as the background. As with all lights, fill-light sources can be feathered, aiming the core of light away from the subject and using just the edge of the beam.

**Hair Light.** The hair light, which is optional if you're on a budget, is a small light. Usually, it takes a scaled-down reflector and a reduced power setting (because hair lights are almost always used undiffused). Because this light is placed behind the subject to illuminate the hair, barn doors or a snoot are a necessity; without such control, the light will flare.

**Background Light.** The background light is also a low-powered light. It is used to illuminate the background so that the subject will separate from it tonally. The background light is usually placed on a small stand directly behind the subject and out of view of the camera. If used this way, the background light is often a barebulb that spills light in a 360-degree pattern. It can also be placed on a higher stand and directed onto the background from either side of the set.

**Kicker Lights.** Kickers are optional lights used very much like hair lights. These add highlights to the sides of the face or body to increase the feeling of depth and richness in a portrait. Because they are used behind the subject, the light just glances off the skin or clothing and

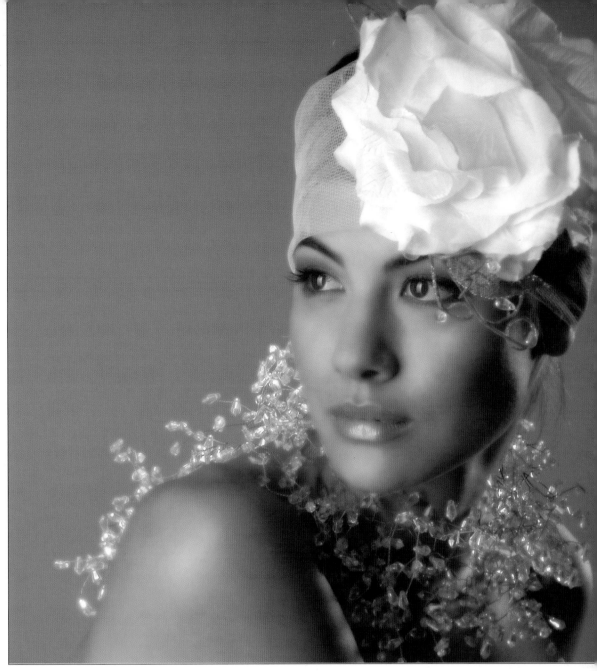

LEFT—Cherie Steinberg Coté is one of the few wedding photographers I know who uses hot lights routinely, both in the studio and on location. Here, Cherie used a 1000K Mole Richardson, positioned by an assistant, to key light the bride and groom, who are framed within the triangle of the steps and balustrades. The exposure of $1/25$ second at f/3.2 was perfect for the available lighting in the building, but Cherie needed to key the subjects so they would stand out. RIGHT—A large softbox lit the bride's face from fairly close in, but a raw (undiffused) kicker came from the opposite side of the model. Notice that the kicker is less intense than the key light so that it is only affecting the shadow side. Notice, too, the elegant highlights created by the backlight. Photograph by Cherie Steinberg Coté.

produces highlights with great brilliance. Barn doors or snoots should be used to control these lights.

## Broad and Short Lighting

There are two basic types of portrait lighting, broad lighting and short lighting. In broad lighting, the key light illuminates the side of the face turned toward the camera. Broad lighting tends to flatten out facial contours and widen the face. In short lighting, the key light illuminates the side of the face turned away from the camera. Short lighting emphasizes facial contours and can be used to narrow a round or wide face. When used with a weak fill light, short lighting produces a dramatic lighting with bold highlights and deep shadows. Because it enhances the shape of the face, short lighting is used more frequently than broad lighting.

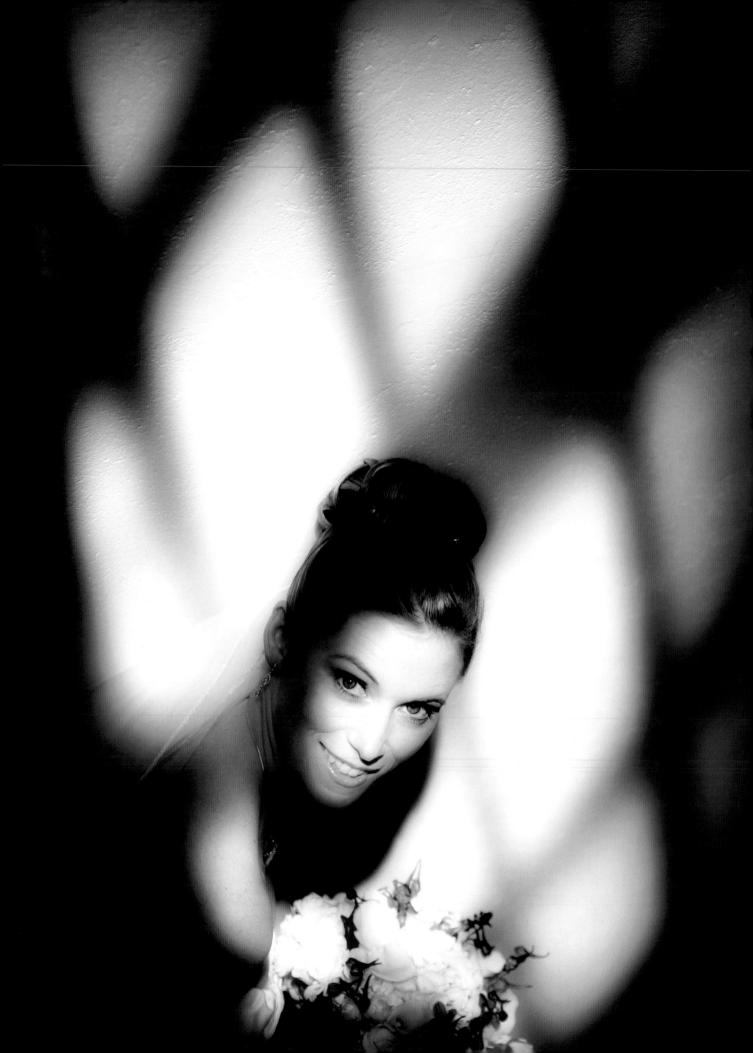

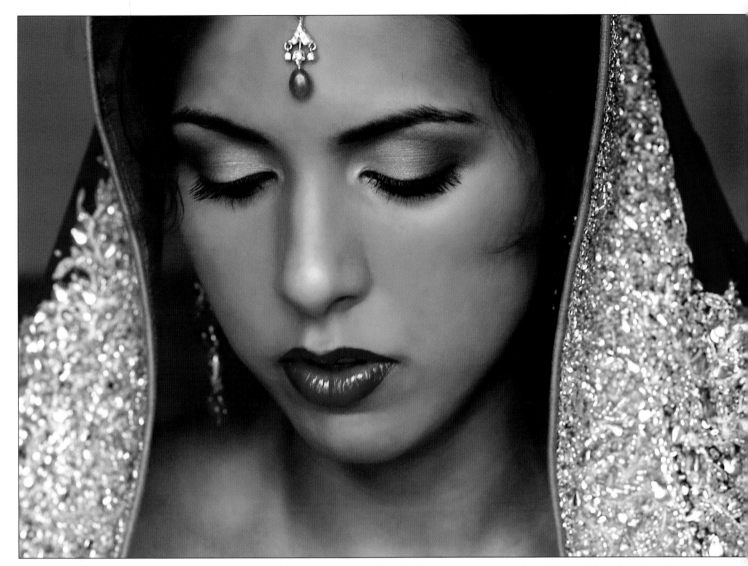

FACING PAGE—Being a good wedding photographer means being an expert at "reading" the light in any portion of the wedding day. Here, Dan Doke spied the sharp but controlled sunlight as it came through a grid of stained-glass windows. The low angle made the light ideal; as you can see, the lighting pattern is between a loop and Paramount lighting pattern. No fill was required. ABOVE—Broad lighting, used much less frequently than short lighting, occurs when the more visible side of the face is highlighted. Photograph by Cherie Steinberg Coté.

### The Five Basic Portrait-Lighting Setups

As you progress through the following lighting setups, from Paramount to split lighting, keep in mind that each pattern progressively makes the face slimmer. Each also progressively brings out more texture in the face because the light is moved father and farther to the side. As you read through the lighting styles, you'll also notice that the key light mimics the course of the sun across the sky; at first it is high, then it gradually grows lower in relation to the subject. It is important that the key light never dip below the subject's head height. In traditional portraiture, this does not occur—primarily because it does not occur in nature.

The setups described below presume the use of parabolic lights. However, you can duplicate the patterns using softboxes for key lights and reflectors as fill-in sources. Very little changes, with the exception that the key light is usually placed closer to the subject in order to capitalize on the softest light.

In such soft-light setups, the background, hair, and kicker lights may also be diffused. For instance, strip lights or similar devices might be used to produce soft, long highlights in hair, on the edge of the subject's clothes, and on the background.

Although most contemporary portrait photographers have been trained to use parabolic lighting, many now

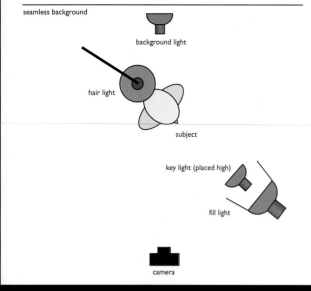

## PARAMOUNT LIGHTING

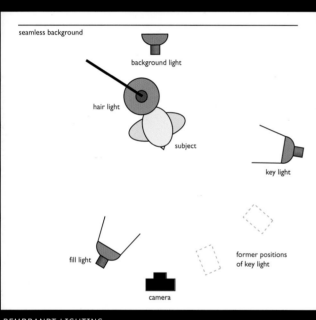

## REMBRANDT LIGHTING

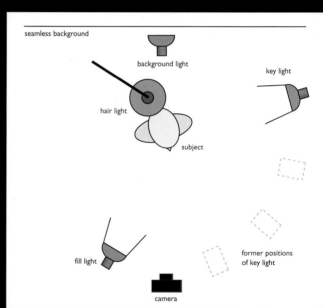

## LOOP LIGHTING

## SPLIT LIGHTING

These diagrams show the five basic portrait lighting setups. The fundamental difference between them is the placement of the key light. Lighting patterns change as the key light is moved from close to and high above the subject to the side of the subject and lower. The key light should not be positioned below eye level, as lighting from beneath does not occur in nature. You will notice that when the key and fill lights are on the same side of the camera, a reflector is used on the opposite side of the subject to fill in the shadows.

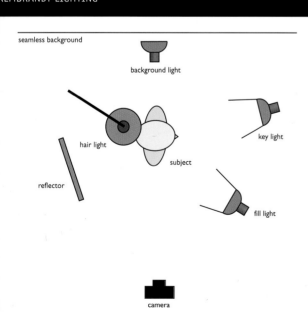

## PROFILE OR RIM LIGHTING

prefer to use diffused light sources, which are more forgiving and do not create sharp-edged shadows.

**Paramount Lighting.** Paramount lighting, sometimes called butterfly lighting or glamour lighting, is a traditionally feminine lighting pattern that produces a symmetrical, butterfly-like shadow beneath the subject's nose. It tends to emphasize high cheekbones and good skin. It is less commonly used on men because it tends to hollow out cheeks and eye sockets too much.

*Key Light.* For this lighting setup, the key light is placed high and directly in front of the subject's face, parallel to the vertical line of the subject's nose (see diagram on facing page). Since the light must be high and close to the subject to produce the desired butterfly shadow, it should not be used on women with deep eye sockets, or no light will illuminate the eyes.

*Fill Light.* The fill light is placed at the subject's head height directly under the key light. Since both the key and fill lights are on the same side of the camera, a reflector must be used opposite these lights and in close to the subject to fill in the deep shadows on the neck and shaded cheek.

*Hair Light.* The hair light, which is usually used opposite the key light, should light the hair only and not skim onto the face of the subject.

*Background Light.* The background light, used low and behind the subject, should form a semicircle of illumination on the seamless background (if using one) so that the tone of the background grows gradually darker the farther out from the subject you look.

**Loop Lighting.** Loop lighting is a minor variation of Paramount lighting. This is one of the more commonly used lighting setups and is ideal for people with average, oval-shaped faces.

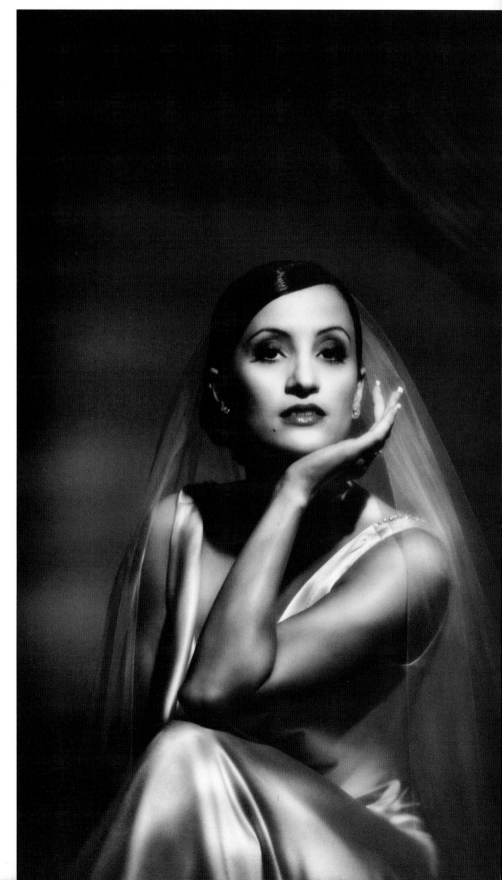

Jerry Ghionis emulated the Hollywood glamour light of the 1940s in this award-winning wedding formal. Note that the shadow created by the main light forms a perfect butterfly shape on the bride's upper lip. Because the main light was positioned high and above the subject, her eyelashes block the light from reaching her eyes, hence the lack of catchlights in her eyes. This effect adds mystery to the overall portrait.

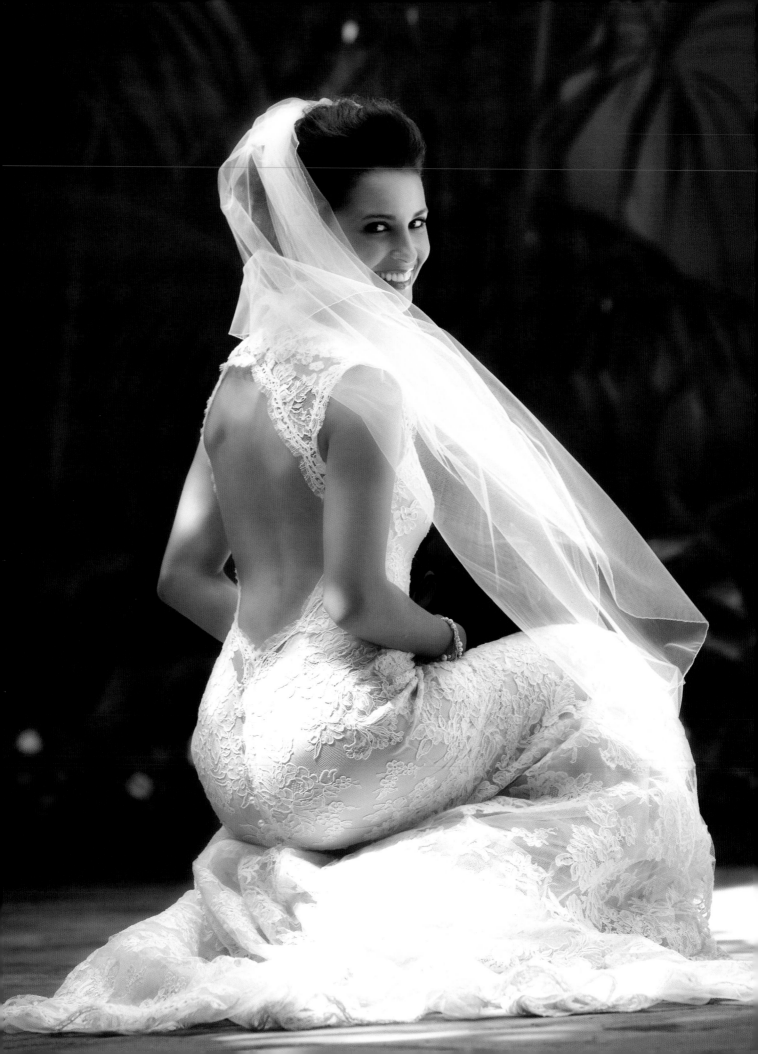

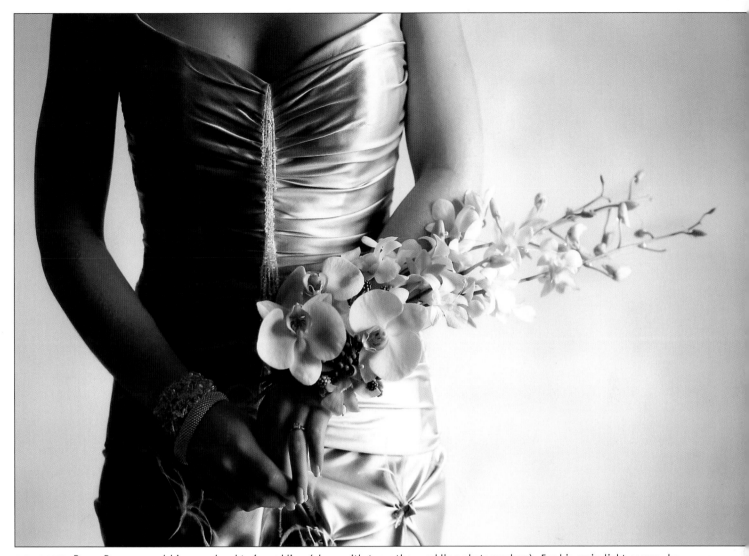

*Key Light.* To create this setup, the key light is low-ered and moved more to the side of the subject so that the shadow under the nose becomes a small loop on the shadow side of the face.

*Fill Light.* The fill light is also moved, being placed on the opposite side of the camera from the key light and close to the camera/subject axis. It is important that the fill light not cast a shadow of its own in order to maintain the one-light character of the portrait. The only position from which you can really observe whether the fill light is doing its job is at the camera. Check carefully to see if

the fill light is casting a shadow of its own by looking through the viewfinder.

*Hair and Background Lights.* The hair and back-ground lights are used in the same way as they are in Paramount lighting.

**Rembrandt Lighting.** Rembrandt lighting (also called 45-degree lighting) is characterized by a small, tri-angular highlight on the shadowed cheek of the subject. The lighting takes its name from the famous Dutch painter who used skylights to illuminate his subjects. This type of lighting is dramatic. It is most often used with

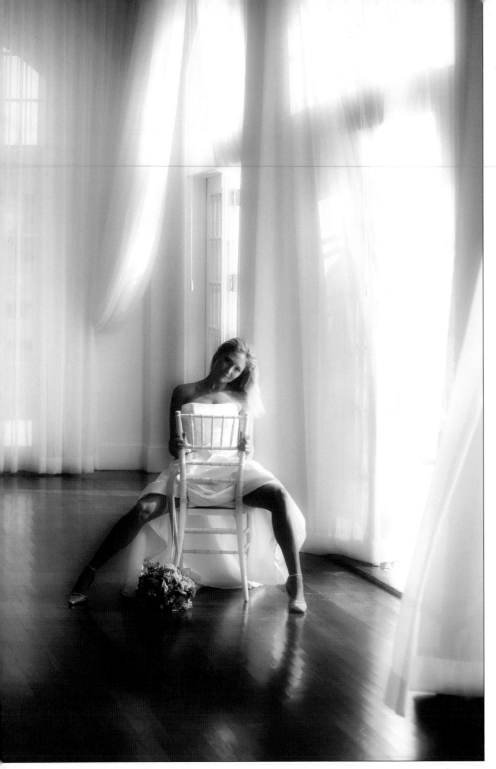

*LEFT*—Split lighting divides the face (and body) in half. It can be a "slimming" light, or as in this case, a dramatic lighting. Dan Doke used a wall of diffused sunlight to key light his bride, with no fill for dramatic effect. Even though the room is lit by "sheers" and the direct sunlight striking these fabrics, Dan decided that the drama came from a significant lighting ratio and altered the image in that direction. *FACING PAGE*—As you look at this photograph by Dan Doke, you might think the hotel's outdoor lighting was very, very bright to create such sharp-edged shadows. Not so. The tungsten lighting is window dressing. The lighting pattern came from a hot (undiffused) strobe positioned behind the couple on a light stand. A diffused fill strobe at the camera position was used to create frontal detail in the image. The working wedding photographer must know how to use existing light as well as when to add his or her own lighting in conjunction with the available light.

The hair light, however, is often used a little closer to the subject for more brilliant highlights in the hair.

*Background and Kicker Lights.* The background light is in the standard position described above. With Rembrandt lighting, however, kickers are often used to delineate the sides of the face (particularly the shadow side) and to add brilliant highlights to the face and shoulders. When setting such lights, be careful not to allow them to shine directly into the camera lens. The best way to check this is to place your hand between the subject and the camera on the axis of the kicker. If your hand casts a shadow when it is placed in front of the lens, then the kicker is shining directly into the lens and should be adjusted.

**Split Lighting.** Split lighting occurs when the key light illuminates only half the face. It is an ideal slimming light. It can be used to narrow a wide face or nose. It can also be used with a weak fill to hide facial irregularities. For a highly dramatic effect, split lighting can be used with no fill.

*Key Light.* In split lighting, the key light is moved farther to the side of the subject and lower than in other

male subjects, and is commonly paired with a weak fill light to accentuate the shadow-side highlight.

*Key Light.* The key light is moved lower and farther to the side than in the loop and Paramount lighting patterns. In fact, the key light almost comes from the subject's side, depending on how far his head is turned from the camera.

*Fill and Hair Lights.* The fill light is used in the same manner as it is when creating the loop lighting pattern.

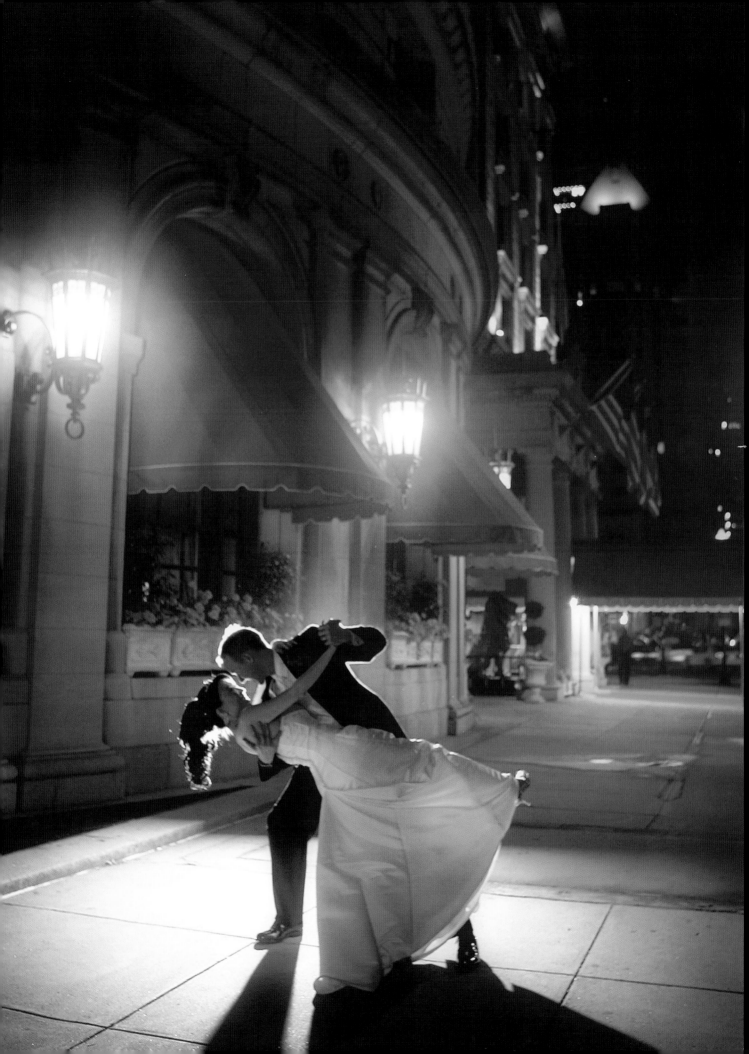

Two-time Pulitzer Prize winner Greg Gibson created this wonderful portrait of the bride getting a last-minute touch-up. Strong backlighting and minimal fill were the keys to this image's success. Backlighting through sheers created the pure white background, while the use of no fill produced the graphic shapes in the near silhouette. If you look at this image carefully, there is plenty of detail visible in the shadows—a result of light bouncing around the room. A good lens shade was a requirement here to avoid image-degrading flare. The image was made at $1/1,000$ second at f/2.8 at ISO 800 as a RAW file. Greg later lowered the exposure values in RAW file processing.

setups. In some cases, the key light is actually slightly behind the subject, depending on how far the subject is turned from the camera.

*Other Lights.* The fill light, hair light, and background light are used normally for split lighting.

**Profile Lighting.** Profile lighting (also called rim lighting) is used when the subject's head is turned 90 degrees from the camera lens. It is a dramatic style of lighting used to accent elegant features. It is used less frequently now than in the past, but it still produces a stylish portrait.

*Key Light.* In rim lighting, the key light is placed behind the subject so that it illuminates the profile of the subject and leaves a polished highlight along the edge of the face. The key light will also highlight the hair and neck of the subject. Care should be taken so that the accent of the light is centered on the face and not so much on the hair or neck.

*Fill Light.* The fill light is moved to the same side of the camera as the key light and a reflector is used to fill in the shadows (see diagram on page 40).

*Hair and Background Lights.* An optional hair light can be used on the opposite side of the key light for better tonal separation of the hair from the background. The background light is used normally.

### The Finer Points

In setting the lights for the basic portrait-lighting patterns discussed here, it is important that you position the lights with sensitivity.

**Overlighting.** If you merely aim the light directly at the subject, there is a good chance you will overlight the subject, producing pasty highlights with no delicate detail. Instead, you must adjust the lights carefully, one at a time, and then observe the effects from the camera position. Instead of aiming the light so that the core of light

strikes the subject, feather it so that you employ the edge of the light. Keep in mind that, since you are using the edge of the light, you will sometimes cause the level of light to drop off appreciably with no noticeable increase in highlight brilliance. In these cases, it is better to make a slight lateral adjustment of the light in one direction or the other. Then check the result in the viewfinder.

**Key-Light Distance.** Sometimes you will not be able to get the skin to "pop," regardless of how many slight adjustments you make to the key light. This probably means that your light is too close to the subject and you are overlighting. Move the light back. A good working distance for your key light, depending on your room dimensions, is eight to twelve feet.

**Fill-Light Distance.** The fill light can pose its own set of problems. If it's too close to the subject, it often produces its own set of specular highlights, which show up in the shadow area of the face and make the skin appear oily. If this is the case, move the camera and light back slightly, or move the fill light laterally away from the camera slightly. You might also try feathering the light in toward the camera a bit. This method of limiting the fill light is preferable to closing down the barn doors of the light to lower its intensity.

**Multiple Catchlights.** Another problem that the fill light often creates is multiple catchlights in the subject's eyes. These are small specular highlights in the iris of the eye. The effect of two catchlights (one from the key light, one from the fill light) is to give the subject a dumb stare or directionless gaze. This second set of catchlights is usually removed in retouching.

This image by Greg Gibson is a lighting tour de force. With a full moon and spot lighting nearby, Greg made the exposure at 1.3 seconds at f/2.8 with his tripod-mounted Canon EOS 5D. To freeze potential camera or subject motion, he fired a flash from the camera position, matching its intensity to the nighttime exposure. If you look closely, you can see a faint black line around the subjects where they moved slightly during the exposure, effectively revealing the darkness behind them. The white balance was set to a custom setting of 6100K to correctly color balance the flash exposure; everything else was warmed by the tungsten lighting. The saturation and brightness were increased in RAW file processing, while the moon and sky were darkened in Photoshop.

...ant, in Brett Florens' view, is an absolute must. From lugging heavy gear around, to ensuring that lenses and other ...quipment are at hand, to manipulating reflectors, the assistant's role is vital. "An assistant is worth his weight in gold, and the finished product is all the better for having him there," he says.

And as Brett favors ambient light for his primary light source, having an assistant work with a reflector becomes even more important. Backlighting ("which lends a romantic feel," he says) is harnessed quite often—especially the setting sun. Brett takes no chances, however, and always has portable studio lighting at hand in case of bad weather. Electronic flash is used for covering formalities at the reception. One light source that produces really spectacular backlighting effects is a two-million-candlepower flashlight, which is operated by an assistant while Brett photographs the wedding couple during their first dance.

Since the launch of the Nikon D100, Brett has shot all digital and, at this writing, is using the Nikon D2X. At each wedding, he downloads his images to a Flashtrax portable storage device. He uses two Power Mac G5s and Adobe Photoshop CS2 back in the studio. Not surprisingly, he has had to hire a full-time graphic designer for color management, digital retouching and other aspects of the digital production process. Visit Brett's website at: www.brettflorens.com.

Brett Florens, one of South Africa's finest wedding photographers, wouldn't be caught dead at a wedding without his assistant and his two-million-candlepower industrial flashlight; as seen here, it can light up a forest without too much trouble. Brett used an on-camera flash to trigger an off-camera flash placed at camera left. This flash gave the lighting a pattern and the on-camera flash, provided slight overall fill to counteract the backlight created by the flashlight and the side light created by the strobe.

## Setting the Lights

Most photographers have their own procedures for setting the portrait lights. You will develop your own system as you gain experience, but the following provides a good starting point.

**Background Light.** Generally, the first light you should set is the background light (if you are using one). Place the light behind the subject, illuminating the part of the background you want lit. Usually, the background light is slightly hotter (brighter) very close to the subject and fades gradually the farther out from the subject you look. This is accomplished by angling the light down-

ward. If you have more space in front of than behind the subject in the composition, the light should be brighter behind the subject than in front (as seen from the camera). This helps increase the sense of direction and depth

*FACING PAGE*—Dan Doke used window light and room light to make this shot. Using a daylight white-balance setting on his Canon EOS-1D Mark IIN, he removed the lampshade from the room light and positioned it behind and to the bride's left so that its warm glow would wrap around and fill the shadows created by the window light. Since he couldn't adjust the intensity of the room light, he moved the bride gradually away from the window until the lighting levels matched. He wanted a good healthy ratio but with warm shadows and a warm-toned background. He vignetted the image in Photoshop as a final touch.

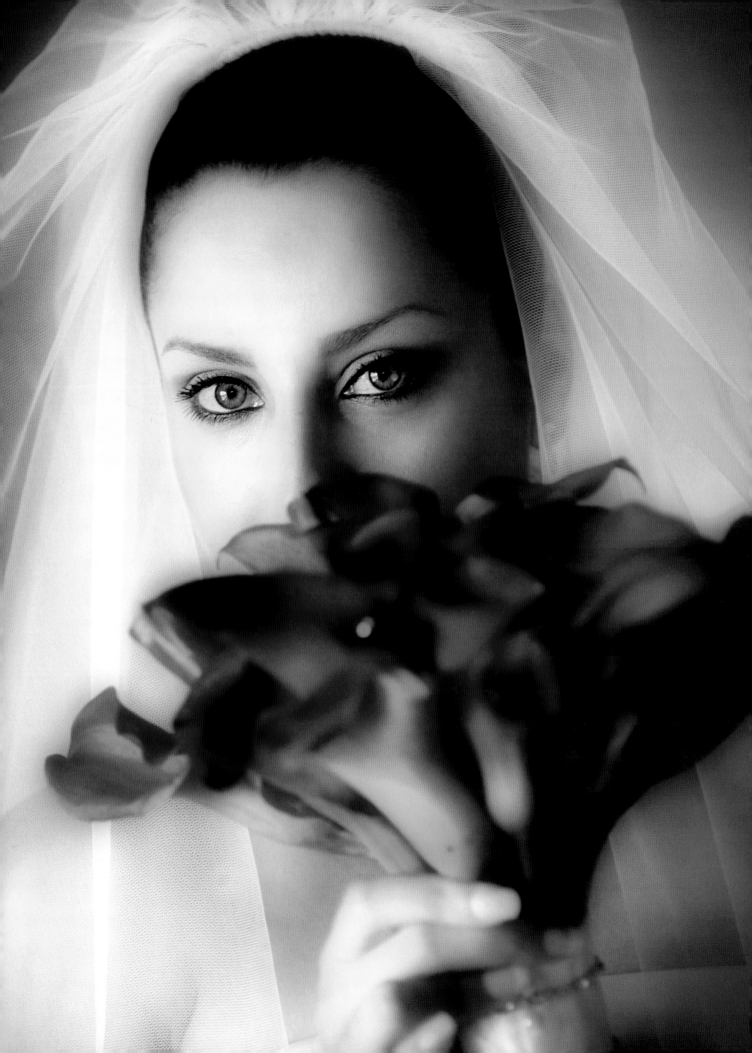

in the portrait. The background light is usually set up while all other lights are turned off.

**Hair Light.** Next, the hair light (if using one) is set. This is also set up with your frontal lights extinguished so that you can see any stray light falling onto the face. If this happens, adjust the light until it illuminates only the hair. When photographing men, the hair light can sometimes double as a kicker, illuminating the hair and one side of the forehead or cheek simultaneously.

**Fill Light.** Next, the fill light is set. Usually it is used next to the camera (see the lighting diagrams on page 40). Adjust it for the amount of shadow detail and lighting ratio you want to achieve. Examine the subject's face with only the fill light on and determine if the skin looks oily or normal. If adjusting the fill light doesn't correct the problem, you will have to use a pancake base makeup to dry up the skin. If the skin looks too matte and lifeless, increase the amount of fill.

**Key Light.** Next, turn on the key light and adjust it for the lighting pattern and ratio you desire. Move it closer to or farther from the subject to determine the ratio you want. Ratios are best metered by holding an incident light meter first in front of the shadow side of the face, and then in front of the highlight side—in each case pointing the meter directly at the light source. Meter the lights independently with the other extinguished. This will give you an accurate reading for each light. Meter the exposure with both frontal lights on and the incident-light dome pointing directly at the camera lens.

# 5. INDOOR LIGHTING

ven when working indoors on location shoots, you cannot always predict the conditions you'll find. You may have to work with what is there. Mixed lighting conditions, fluorescent tubes everywhere, no light to speak of, or harsh direct sunlight streaming in open windows—these are all conditions you can (and will) find the minute you leave the friendly confines of the studio. However, being on location can be a challenge and a thrill, and some photographers have developed lighting systems that work as well as, if not better than studio lighting.

## Continuous vs. Instantaneous Light Sources

It doesn't matter whether you choose continuous or instantaneous light sources; each has its advantages. Strobe lighting requires less power to operate than continuous sources and puts out little or no heat. However, portable flash units have no modeling lights, making predictable results difficult—if not impossible. Even with studio flash, the built-in modeling lights may not offer a precise preview of what you'll get in your image. Continuous light sources, on the other hand, let you see exactly the lighting effect you will get, since the light source is both the modeling light and the actual shooting light (just remember to use a tungsten-balanced film or adjust the white-balance setting to match the light source).

### MODELING LIGHTS
Portable flash units have no modeling lights, making predictable results difficult, if not impossible. If you are using continuous light sources, or studio flash with built-in modeling lights, you can see the effect of the lighting while you are shooting. There is also much more light available for focusing with either of these systems.

### How to Light Wedding Groups
Wedding photography commonly includes a number of group portraits—the bridal party, the groom's family, the bride's family, the extended new family, and so on.

The best photographers are compelled by lines they observe within a scene. Here, Marcus Bell left the color balance set to daylight, which recorded the strong orange hue of the tungsten hotel lights.

*FACING PAGE*—Umbrellas and bounce flash are ideal for photographing candid moments and making formal portraits. Mauricio Donelli makes it a point to bring strobes, softboxes, and umbrellas—as well as an assistant to lug these things around. Here, a softbox was set up to light the bride frontally while Mauricio photographed her from the side. No fill was used to get some lighting contrast into the image. Notice how the side lighting of the softbox skims the surface of the dress, revealing beautiful details. This image was made outdoors in the late afternoon. To make it look later in the day, Mauricio exposed for the flash and not the daylight. *TOP RIGHT*—A dark hallway and a priceless moment—there was no time for anything but bounce flash off the ceiling, which not only preserved the moment, but was the perfect lighting choice for this image, giving it a journalistic real-time look. Photograph by Marcus Bell. *BOTTOM RIGHT*—There will be times when the photographer has to be invisible; otherwise, the moment will be destroyed. Such was the case here, where Marcus Bell photographed a couple intently focused on the toasts by candlelight. The light was very dim, but acceptable and made better by being able to increase the ISO to 1600. Even so, he still had to shoot at a ridiculously long shutter speed of $^1/_8$ second at f/2.8. Situations like this often demand you shoot in RAW mode so you can later decrease the noise created by shooting at higher ISOs.

**Types of Lights.** Umbrella lights are the best choice for lighting large groups. Usually, the umbrellas are positioned on either side of the camera, equidistant between the group and the camera so the light is even. The lights should be feathered so there is no hot center. These units should also be slaved (with either radio or optical slaves) so that when the photog-

rapher triggers the main flash, all of the umbrellas will fire in sync. Monolight-type strobes work best for this type of application since they have a photo slave built in for just such situations.

Another means of lighting large groups is to bounce undiffused strobes off the ceiling to produce an overhead soft light. This light will produce an even overall lighting but not necessarily the most flattering portrait light. You can, however, pair this light with a more powerful (by about one stop) umbrella flash at the camera. Placed slightly higher than the group and slightly to one side,

this will produce a pleasant modeling effect. The bounce light then acts as fill, while the umbrella flash acts as the key light. Be sure to meter the fill and the key lights separately and expose for the key.

Quartz-halogen lights can be used similarly, although you must use tungsten-balanced film or choose a tungsten (or custom) white-balance setting for your digital camera. Hot lights provide the same flexibility as strobes—and perhaps even more, because you can see the light fall-off. When shooting, you can also use your in-camera meter for reliable results.

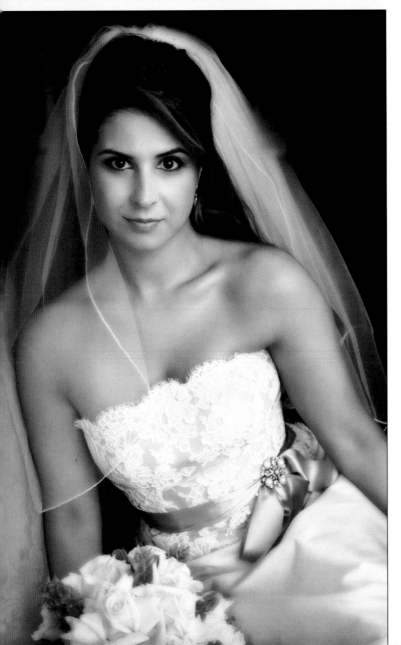

ABOVE—This is a remarkable mixed-light photograph of the bride and her bridesmaids taken in a hotel lobby by Al Gordon. Out of view to the right are long floor-to-ceiling windows that let in beautiful, soft light. One window, in particular, lit the area where the bride stood. The rest of the lighting is a mixture of room light from the lobby's candelabras and chandeliers. LEFT—Scott Robert Lim created this beautiful window-light portrait by placing his bride in front of a very large window. According to Scott, "It was near the end of day and all the windows were facing east, so I tried to find the largest natural light source on the east side. I was standing to the left and I think my body blocked part of the light, which accounts for the lighting ratio and also why the catchlight in her right eye looks smaller." FACING PAGE—Jeff and Julia Woods positioned their bride far enough from a large window to create a full-length portrait. The farther you move your subject from the window, the more light falls off and the more contrast there is. Here, the lighting was still soft and forgiving enough to require no fill. The exposure was $^1/_{40}$ second at f/2.8 at ISO 800.

One word of caution about using hot lights: if adjusted with a dimmer switch, the color temperature will drop with the light intensity. Since it is relatively unpredictable, shoot in RAW and use an automatic white balance setting. If necessary, you can then correct the color balance in the RAW file processing.

**Even Lighting.** Whether you're using quartz lights or strobes in umbrellas, it is imperative that the lighting is even across the group—left to right and front to back. Any deviation of more than ⅓ stop will be noticeable, particularly if shooting digital in the JPEG mode. It is a good idea, when you set the lights, to have an assistant

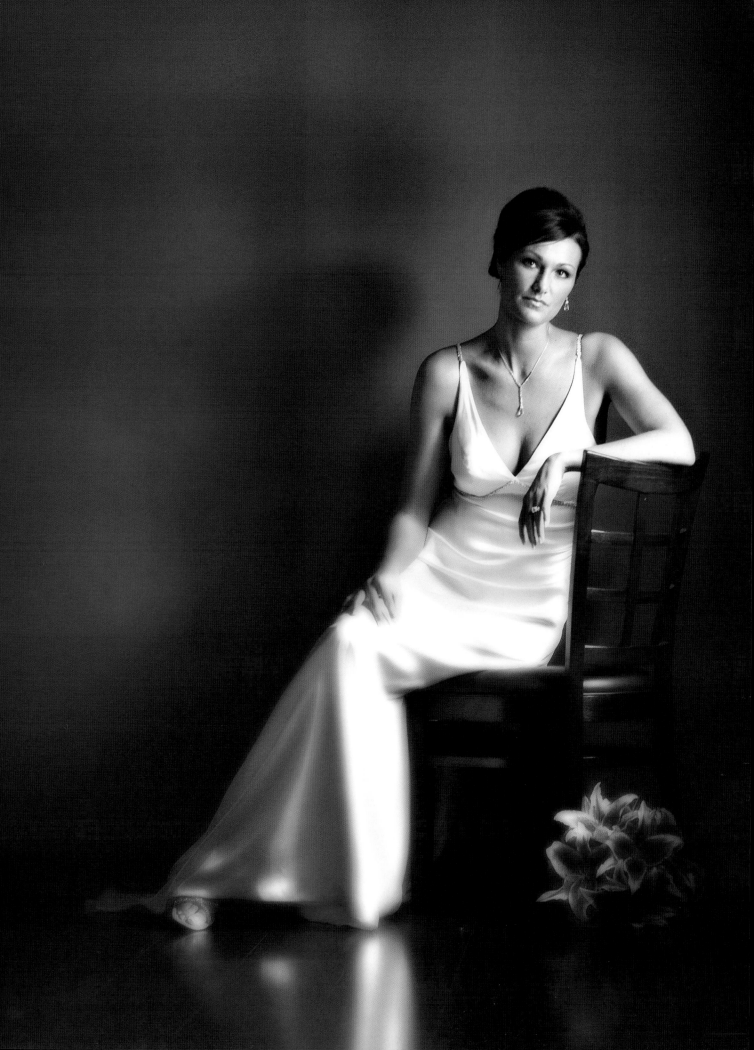

meter the corners and center of the group to confirm that the lighting is even.

**Light Positions.** It is irrelevant to talk about portrait lighting patterns here (like Paramount, loop, and Rembrandt lighting). Instead, you should be concerned about getting the lights high enough to model the subjects' faces, and getting the light off to the side so that it is not a flat frontal lighting. But again, these aspects of the light-

*LEFT*—Window light can fall off rapidly in intensity. One way to correct for this is to group the faces closely so that there is little difference in exposure between the face closest to the window and the one farthest away. Within moderate limits, one can correct for such falloff with minor dodging and burning-in in Photoshop. Photograph by Fernando Basurto. *BELOW*—The Spanish-style portico is like window lighting on steroids. You get the benefits of intensity, directionality, and softness—without having to shoot at $\frac{1}{8}$ second. Here, Bruce Dorn took advantage of this light quality and intensity to create an action portrait that is truly priceless. He further worked the image in Painter and Photoshop to create a genuine work of art.

### DAVID BECKSTEAD: USING THE LIGHT YOU'RE GIVEN

"The concept of quality of light may have played too large a part with many wedding photographers before us. You are given only what the weather and the bride's timeline allows. Part of being perceptive is learning how you change and flow with what really happens at your wedding, hour after hour. Finding the perfect quality of light will often elude you. It's best to make use of the harsh light, the bad light, the poor-quality light, and then pull out all the stops of perception by working these types of light to your advantage. It's all in your head! Being perceptive about what your camera can do beyond the priority-modes will give you tools of exposure to counteract the bad light. My advice—practice daily until you are comfortable with Aperture-priority mode and Manual mode. Be the alpha-dog of your camera! Don't let it make all the decisions!"

Bad light, good light; it doesn't really matter to David Beckstead who is determined to use whatever he is given or can create. Here, a naturally lit scene presents itself and the result is a beautiful detail shot of the bride and her dress and jewelry. Direct sunlight cascades down from behind, so Beckstead decided to use its texture-revealing sharpness to enhance the wonderful skin of the bride and the rich detail of the dress. It was a matter of repositioning himself and his bride until the sharp-edged light did what he knew it could do. The result is an award-winning image.

ing are dictated by the size of the group and the area in which you must photograph them. What is important is that you create a one-light look, as you'd find in nature, with no double sets of shadows.

**Feathering.** If you aim a light source directly at your group, you will find that, while the strobe's modeling light might trick you into thinking the lighting is even, it is really falling off at the ends of the group. Feathering, aiming the light source past the group so that you use the edge of the light instead of the core, will help to light your group more evenly. Always check the results in the viewfinder and with a meter. If shooting digitally, fire a few test frames and review them on the camera's LCD.

Another trick is to move the light source back so that it is less intense overall, but covers a wider area. The light will be less diffused the farther you move it back.

**Focus.** Since you will be using the lens at or near its widest aperture, it is important to focus carefully. Focus on the eyes and, if necessary, adjust members of the group forward or backward so they fall within the same focal plane. Depth of field is minimal at these apertures, so control the pose, focus as carefully as possible, and be sure light falls evenly on all the faces.

### Window Light

**Advantages.** One of the most flattering types of lighting you can use is window lighting. It is a soft, minimizing facial imperfections, but also highly directional, yielding good roundness and modeling in portraits. Window light is usually a fairly bright light and it is infinitely variable, changing almost by the minute. This allows for a great variety of moods in a single shooting session.

**Challenges.** Window lighting also has several drawbacks, though. Since daylight falls off rapidly once it enters a window, it is much weaker several feet from the window than it is close to the window. Therefore, great care must be taken in determining exposure—particularly with groups of three or four people. Another problem arises from shooting in buildings not designed for photography; you will sometimes encounter distracting back-

grounds and uncomfortably close shooting distances.

**Direction and Time of Day.** The best quality of window light is found at mid-morning or mid-afternoon. Direct sunlight is difficult to work with because of its intensity and because it often creates shadows of the individual windowpanes on the subject. It is often said that north light is the best for window-lit portraits, but this is not necessarily true. Good quality light can be had from a window facing any direction, provided the light is soft.

**Subject Placement.** One of the most difficult aspects of shooting window-light portraits is positioning your subjects so that there is good facial modeling. If the subjects are placed parallel to the window, you will get a form of split lighting that can be harsh and may not be right for certain faces. It is best to position your subjects away from the window slightly so that they can look back toward it. In this position, the lighting will highlight more areas of the faces.

The closer to the window your subjects are, the harsher the lighting will be. The light becomes more diffused the farther

you move from the window, as the light mixes with other reflected light in the room. Usually, it is best to position the subjects about three to five feet from a large window. This not only gives better lighting, but also gives you a little room to produce a flattering pose and pleasing composition.

**Metering.** The best way to meter for exposure is with a handheld incident meter. Hold it in front of each subject's face, in the same light as the subject, and take a reading with the light-sensitive hemisphere pointed directly at the camera lens.

With more than one subject you'll get multiple readings. Choose an exposure midway between the two or three readings. Whatever direction the faces are turned (*i.e.,* toward the window or toward the camera), make the meter's hemisphere mimic the same angle for a more accurate reading.

If using a reflected meter, like the in-camera meter, move in close and take readings off the faces. If the subjects are particularly fair-skinned, remember to open up at least one f-stop from the indicated reading. Most camera light meters take an average reading, so if you move in close on a person with an average skin tone, the meter will read the face, hair, and what little clothing and background it can see and give you a fairly good exposure reading. Average these readings and choose an intermediate exposure setting.

**White Balance.** If shooting digitally, a custom white-balance reading should be taken, since most window-light situations will be mixed light (daylight and room light). If working in changing light, take a new custom white-balance reading every twenty minutes or so to ensure that the changing light does not affect the color balance of your scene. Alternatively, shoot in RAW capture mode, which will allow you to fine-tune the color balance after capture.

**Fill Light.** *Reflectors.* The easiest way to fill the shadows is with a large white or silver fill reflector placed next to the subjects on the side opposite the window, angled up to catch incoming light and reflect it back on the group. Setting the proper angle takes some practice and is best handled by an assistant so that you can observe the effects in the viewfinder.

*Room Lights.* If a fill card is not sufficient, it may be necessary to provide another source of illumination to achieve good balance. Sometimes, flicking on a few room lights will produce good overall fill-in by raising the ambient light level. If you do this, however, be sure the lights do not overpower the window light, creating multiple lighting patterns. Keep in mind that you will get a warm glow from the

Greg Gibson's base exposure for the scene was $1/20$ second at f/2.8. He fired an on-camera flash to freeze his subjects and ensure he would not lose the priceless moment. Notice that the combination of straight flash and available light is not nearly as harsh as direct flash when it overpowers the existing light.

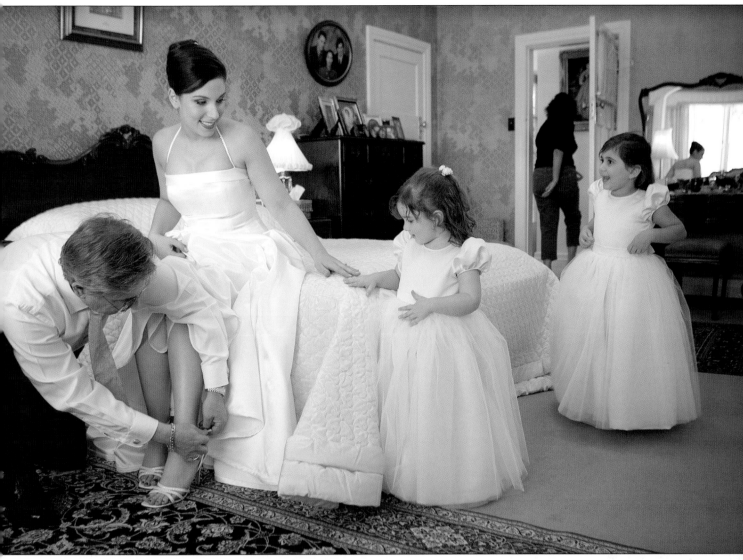

One of the best types of window light is that from two windows facing different directions. Here, Marcus Bell availed himself of the great light in the upstairs bedroom of the bride's house. The light was soft, diffused by sheer curtains, and there was plenty of it. He made the exposure at $^1/_{80}$ second at f/2.8 at ISO 400 with a 24–70mm f/2.8 lens set to 24mm.

tungsten room lights if you are using daylight-balanced film or a daylight white-balance setting. This is quite pleasing if it's not too intense.

It is also a good idea to have a room light in the background behind the subjects. This opens up an otherwise dark background and provides better depth in the portrait. If possible, position the background room light behind the subject, out of view of the camera, or off to the side, out of the camera's field of view so it lights the wall behind the subjects.

*Bounce Flash.* If none of the above methods of fill-in is available to you, use bounce flash. You can bounce the light from a portable electronic flash off a white card, the ceiling, an umbrella, or a far wall—but be sure that it is

### SMALL LIGHTS FOR TIGHT SPACES

Bruce Dorn, whose first career as a cinematographer earned him countless awards and credits, knows light. And he knows how to mix light sources like a master. One of his favorite little lights for tight spaces is the Frezzi Mini-Fill dimmable Sungun. Its output ranges from 20 to 100 watts, depending on the lamp installed, and its undiffused output is, according to Dorn, "universally nasty." But combined with a mini softbox, this light is especially useful as a close-up key light. It reacts extremely well to feathering, where you redirect the core of the light away from the subject, using the edges of the light for the most dynamic effect.

½ to one f-stop less intense than the daylight. When using flash for fill-in, it is important to carry a flashmeter to determine the intensity of the flash.

**Diffusing Window Light.** If you find a nice location for a portrait but the light coming through the windows is direct sunlight, you can diffuse it by taping acetate diffusing material to the window frame. This produces a warm, golden window light. Light diffused in this manner has the feeling of warm sunlight but without the harsh shadows. If it's still too harsh, try doubling the thickness of the acetate for more diffusion. Since the light is so scattered by the scrim (the term for these diffusers

in the movie industry), you will probably not need a fill source. Even without fill, it is not unusual to have a low lighting ratio in the 2:1 to 2.5:1 range. The exception is when you are working with a larger group. In that case, use reflectors to bounce light back into the faces of those farthest from the window.

Scrims are sold commercially and come in large sizes up to 8x8 feet or so. Like portable reflectors, these scrims are supported on a flexible frame that folds down to about a quarter of the scrim's extended size. When extended, they are rigid and will fit nicely inside a large window frame.

Light is where you find it and what you make of it. Yervant had his bride stop under a hotel "can" light; an overhead spot that lights a small area of the wall and carpet with a sharp, hot light. He positioned her so that the single light would reveal her shape and had her glance up into the light to create highlights on the frontal planes of her face. She liked it so much that it ran over two pages in the bride's wedding album.

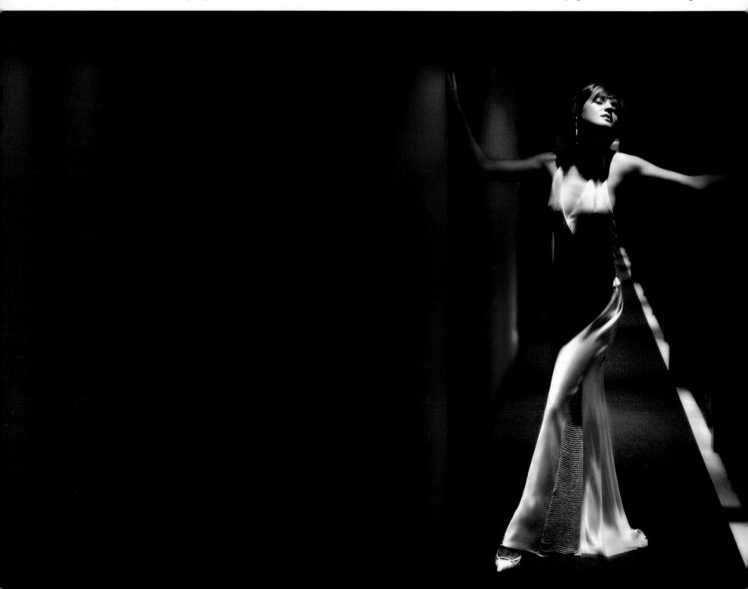

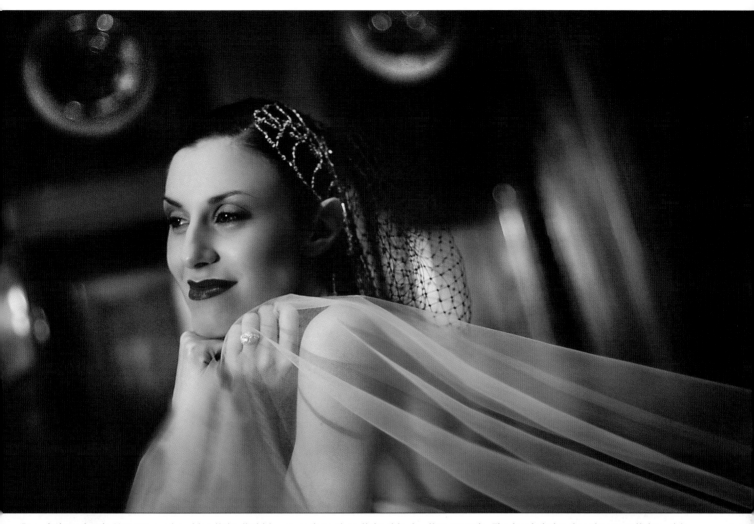

In a darkened pub, Yervant used a video light (held by an assistant) to light this dazzling portrait. The key is balancing the room lights with the video light, which is easy to do by either decreasing the power of the video light or feathering the light's core away from the subject.

### Mastering One Light

If you want to improve your location-portrait lighting techniques drastically in a relatively short time, learn to use one light to do the job of many. One light can effectively model the features of a single subject or small group with relative ease. Whether you own strobe, portable, or studio-flash equipment, tungsten or quartz-halogen lighting equipment, you will get your money's worth from it by learning to use one light well. You will also better understand lighting and learn to "see" good lighting by mastering a single light.

**Handheld Video Lights.** Photographer David Williams uses small handheld video lights to augment existing light at a wedding or on location. He glues a Cokin filter holder to the front of the light and places a medium blue filter (a 025 Cokin) in the holder. The filter brings the white balance back from tungsten to about 4500K,

which is still slightly warmer than daylight. It is the perfect warm fill light. If you want an even warmer effect, or if you are shooting indoors with tungsten lights, you can simply remove the filter.

These lights sometimes have variable power settings. Used close to the subject (within ten feet) they are fairly bright, but can be bounced or feathered to cut the intensity. David uses them when shooting wide open, so they are usually just employed for fill or accent.

The video light can also be used to provide what David calls, a "kiss of light." He holds the light above and to the side of the subject and feathers it back and forth while looking through the view-finder. The idea is to produce just a little warmth and light on a backlit object or something that is lit nondescriptly.

Sometimes he uses an assistant to hold two lights, each canceling out the shadows from the other. He often

### DAVID BECKSTEAD ANALYZES HIS LIGHT FIRST

"Let's take a nice hotel bridal-suite layout," says David. "The bride is in the open-door bathroom putting on makeup; the bridesmaids are getting ready in front of the mirrors located around the main room. What type of lighting do you have? How does the natural light play on room and subjects? How does the tungsten light mix with the natural light? How do the lines of the room interact with the subjects? What is in the way of compositions? What will enhance them?"

According to David, these are questions you can nail down in one minute of careful observation. The problem many photographers have, he says, is that they don't take that minute. "The tendency is to go directly to the subjects and start shooting without taking a moment to see all," he says.

David begins preparing for his photography well before the wedding by setting the stage for great images. For example, he asks brides to plan on putting on their makeup and getting their hair done in areas with good window light. If they forget, he may ask the bride to step out of the tungsten-lit bathroom and into the natural light. "But before I do this," he notes, "I walk into the bathroom and see if there are other compositional elements that help equal out my desire for nice natural light windows. I may find that the mirrors, reflective surfaces, angles and lines in the bathroom give me more room for creative play."

"How do you see what is there very quickly and how best to utilize it?" asks David. "I have a method that works: walk into the room, squint your eyes so all the complexity of the room fades away to nothing but darks and lights. Then, open your eyes widely and go to the light. Stand next to the light or in it, and then look for your intended subjects. Now first, see if this natural light can be used as a line, a pointer, or a guide to your subjects for a creative image. Then back off and evaluate how the light can be used in a composition. Now that you have the natural light in a room dialed-in, get your first 'safe' shot (often using the natural light) and utilize your time between other upcoming 'safe' shots to be artistic."

Perceiving the light and how it is working in a space is paramount to David Beckstead. Here, the photographer found his shot reflected in the glass of a framed print in the bridal suite.

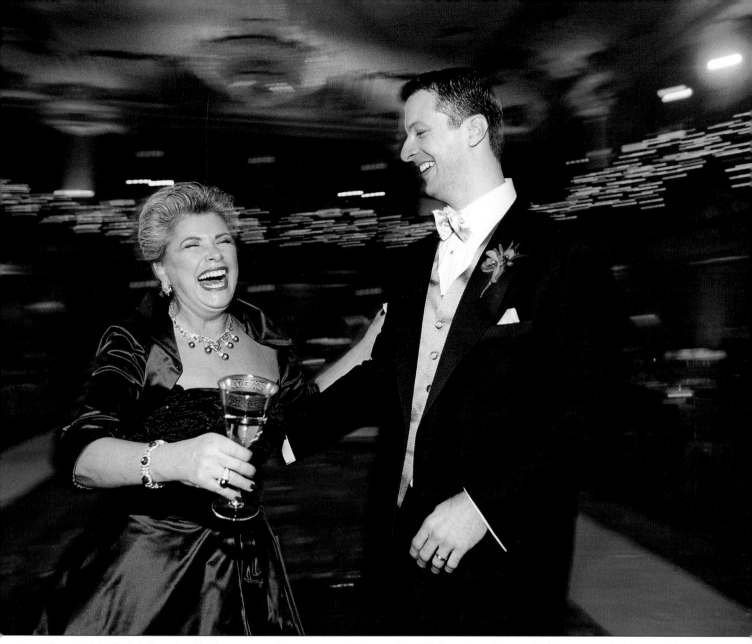

Sometimes straight flash is the only effective way to make an exposure. Photographer Cliff Mautner used a very slow shutter speed and panned the camera in the dim light to blur the background lights. The on-camera flash fired at the instant of hilarity, creating a priceless image.

combines these in a flash-bracket arrangement with a handle. His video light has a palm grip attached to the bottom to make it more maneuverable when he has the camera in the other hand.

**Diffused "Straight" Flash.** On-camera flash should be avoided for making portraits, unless it is used as a fill-in source. Its light is too harsh and flat and it produces no roundness or contouring of the faces. However, when you diffuse on-camera flash, you get a softer frontal lighting, similar to fashion lighting (see sidebar on page 67). While diffused flash is still a flat lighting and frontal in nature, its softness produces much better contouring than direct, undiffused flash.

There are various devices on the market for diffusing on-camera flash. Most can even be used with your flash in auto or TTL mode, making exposure calculation effortless. Nikon offers retractable diffusion panels for its high-end SB Speedlights that provide full TTL operation with the diffuser in place.

**Bounce Flash.** Portable electronic flash is the most difficult of one-light applications. Because portable flash units do not have modeling lights, it is impossible to preview the lighting effect you will achieve. Still, when it is bounced off the ceiling or a side wall, portable flash produces efficient wraparound lighting that illuminates portrait subjects beautifully. The key is to aim the flash unit

at a point on the wall or ceiling that will produce the widest beam of light reflecting back onto your subjects. Also, keep in mind that you should never bounce flash off colored walls or ceilings. The light reflected back onto your subjects will be the same color as the walls or ceiling and it will be almost impossible to correct, whether you're shooting film or digital.

*Bounce-Flash Accessories.* Many photographers use their on-camera flash in bounce-flash mode. A problem, however, with bounce flash is that it produces an overhead soft light. With high ceilings, the problem is even worse; the light source, while soft, is almost directly overhead. There are a number of devices on the market, like the Lumiquest ProMax system, that allow most of the flash's illumination to bounce off the ceiling while some is redirected forward as fill light. This solves the overhead problem of bounce flash. The Lumiquest system also includes interchangeable white, gold, and silver inserts as well as a removable frosted diffusion screen.

Lumiquest also offers devices like the Pocket Bouncer, which enlarges and redirects light at a 90-degree angle from the flash to soften the quality of light and distribute it over a wider area. While no exposure compensation is necessary with TTL flash exposure systems, operating distances are somewhat reduced. With both systems, light loss is approximately $1\frac{1}{3}$ stops; with the ProMax system, however, using the gold or silver inserts will lower the light loss to approximately $\frac{2}{3}$ stop.

### Multiple Lights
**Remote Triggering Devices.** If using multiple flash units to light an area, some type of remote

Rick Ferro is master at lighting. Here he used soft, on-axis lighting and a brilliant white background to create high-key glamour lighting. A reflector positioned beneath the camera and close to the bride kicked a lot of the white light from the strobe-lit background back onto the bride's face, creating a very pleasing frontal fashion lighting. In order to create a little dimension on the cheekbones, some shading was done in Photoshop.

A good bounce-flash accessory is the Omni Bounce, a frosted cap that fits over the flash head to diffuse the beam of light. The Omni Bounce is made to fit the popular Canon and Nikon speedlights.

triggering device will be needed to sync all the flash units at the instant of exposure. There are a variety of these devices available; by far the most reliable, however, is the radio-remote triggering device. When you press the shutter release, it transmits a radio signal (either digital or analog) that is received by individual receivers mounted to each flash. Digital systems, like the Pocket Wizard Plus, are state of the art. Complex 16-bit digitally coded radio signals deliver a unique code, ensuring the receiver cannot be triggered or "locked up" by other radio noise. The built-in microprocessor guarantees consistent sync speeds even under the worst conditions. Some photographers use a separate transmitter for each camera, as well as a separate one for the handheld flashmeter, allowing the photographer to take remote flash readings from anywhere in the room.

### ON-AXIS FASHION LIGHTING

Fashion lighting is a variation of conventional portrait lighting. It is extremely soft and frontal in nature—in fact, the key light is usually on the lens/subject axis. Because the key light produces almost no shadows, makeup is frequently used to produce contouring. It is a stark lighting that is usually accomplished with a large softbox directly over the camera and a silver reflector just beneath the camera. Both the light and reflector are very close to the subject for the softest effect.

When you examine the catchlights in a fashion portrait you will see two—a larger one over the pupil and a less intense one under the pupil. Occasionally, you will see a circular catchlight produced by a ringlight flash—a macrophotography light that mounts around the lens for completely shadowless lighting.

A conventional softbox on its own light stand will not work for this type of lighting because the stand gets in the way. Usually a softbox that is mounted to a boom arm, which is counterweighted for balance, is the way to go. A silver reflector is often used beneath the camera lens and angled up at the face. The result is a wide beam of frontal light that minimizes texture.

### BRUCE DORN AND THE INBETWEENIE

At his weddings or in his formal sessions, Bruce Dorn frequently uses a hot light that is popular with filmmakers. It is the Mole-Richardson 200-watt InBetweenie SolarSpot. These Fresnel-lens fixtures are full-featured but miniature versions of the Hollywood original. They come with their own assortment of light-shaping accessories, including barn doors, snoots, and single and double metal wire scrims (which reduce intensity without a color shift). A drop-in filter frame allows you to use high-quality gel filters for either color-correction or a theatrical effect. A choice of different wattages for the easily replaced incandescent globes means you can accurately match the intensity of your ambient light without resorting to dimmers, which unpredictably reduce the color temperature. The width and characteristic of the InBetweenie lets you select lighting modes from flood to spot and anywhere "in between(ie)." They are ideal for close working distances, such as in dressing rooms. Because you can vary the wattage of the globe used, you can also create a fill or key light that matches your exact shooting situation.

# 6. OUTDOOR LIGHTING

Nature provides every lighting variation imaginable. That's why so many images are made with it. Often, the light is so good that there is just no improving on it. For example, I used to work for a major West Coast publishing company that specialized in automotive publications. One of the studios that was used for photographing cars was massive, with a ceiling that was between three and four stories high. Below the ceiling was a giant scrim suspended on cables so that each of the four corners could be lowered or raised. Huge banks of in-

Learning to see light is a skill that good photographers acquire over time. In this beautiful image by Jeffrey and Julia Woods, the light was diffused backlight from late afternoon sun with a scattered overcast sky. The Woods positioned the couple so that the groom's face received the reflected light from the bride and her white dress, both natural reflectors. The lighting ratio is a beautiful a 2.5:1. The image was made with a Canon EOS 1D Mark II and 70–200mm f/2.8 lens at 200mm. The film speed was ISO 160 and the exposure was $^{1}/_{1,000}$ second at f/3.2.

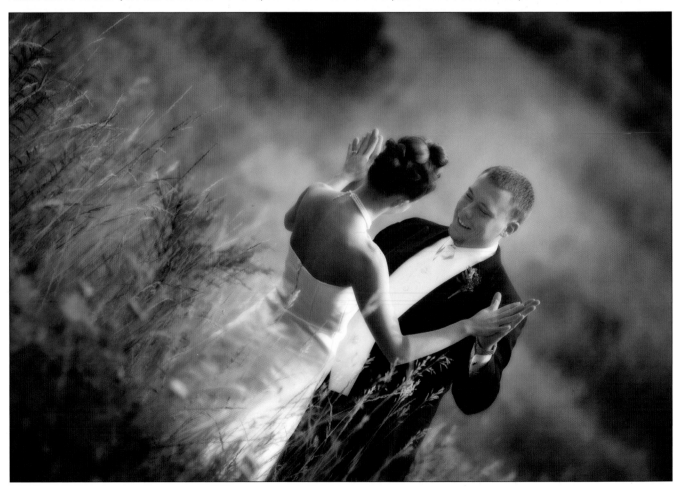

Marc Weisberg employed a tent overhang to block the afternoon light from overhead. With this in place, the light filtered in from the sides, front, and back. Notice the specular highlights on the right side of the bride's face caused by intense reflections coming from that direction (probably off of a building). The light is plentiful and frontal in nature and, because of the tight cropping used, the exposure can be biased exclusively for the faces, letting the background burn out.

candescent lights (twelve and sixteen lights to a bank) were bounced into the scrim from overhead catwalks to produce a huge milky-white highlight the length of the car—a trademark of automotive photography. The studio was used when a car could not be photographed outside in public or when it was only on loan to the magazine (*Motor Trend*) for a very short time. Despite the availability of this space, if time and the weather were on their side, the staff photographers would invariably opt to photograph the car at twilight, when the setting sun, minutes after sunset, created a massive skylight in the Western sky. No matter how big or well equipped the studio, nature's light is far superior in both quantity and quality (although it fades rather quickly).

### Finding the Right Light

**Shade.** In order to harness the power of natural light, one must be aware of its various personalities. Unlike the studio, where you can set the lights to obtain any effect you want, in nature you must use the light that you find or alter it to suit your needs. By far the best place to make outdoor images is in the shade, away from direct sunlight.

Shade is nothing more than diffused sunlight. Contrary to popular belief, shade is not directionless. It has a very definite direction. The best shade for any photographic subject, but primarily for people, is found in or near a clearing in the woods. Where the trees provide an overhang above the subjects, the light is blocked. From the clearing, diffused light filters in from the sides, producing better modeling on the face than in open shade. (Open shade is overhead in nature and most unflattering. Like noontime sun, it leaves deep shadows in the eye sockets and under the nose and chin of the subjects. If forced to shoot in open shade, you must fill-in the daylight with a frontal flash or reflector.)

ABOVE—In the manicured gardens of a Scottish castle, Dennis Orchard found the daylight to his liking. Walking along a tree-covered path, Dennis saw that the light on his bride and groom was coming in from the sides (blocked overhead by the trees), creating a directional, pleasing lighting pattern. FACING PAGE—Midday light doesn't have to be harsh—especially where tall buildings block the direct light and create an atmosphere of open shade. The light is, however, overhead in such situations. Knowing this helped Mike Colón, who waited until the bride's head was raised, taking advantage of the soft overhead light. Mike also used a radical new telephoto lens, Nikon's 200mm f/2.0, which cuts scene contrast and lighting contrast.

Another popular misconception about shade is that it is always a soft light. Particularly on overcast days, shade can be harsh, producing bright highlights and deep shadows, especially around midday. Instead, move under an overhang, such as a tree with low-hanging branches or a covered porch, and you will immediately notice that the light is less harsh and that it also has good direction. The quality of light will also be less overhead in nature, coming from the side that is not obscured by the overhang.

**Working at Midday.** Because most ceremonies are held during these hours, working at midday is a necessity for the wedding photographer. This means you will be forced to use the light that is available.

The best system if working at midday is to work in shade exclusively. Try to find locations where the background has sunlight on dark foliage and where the difference between the background exposure and the subject exposure is not too great. As it is often impossible to avoid photographing out in the open sunlight on wedding days, the best strategy is to use the sun as a backlight and bias the exposure towards the shadow side(s) of the subject(s). This is where it's advisable to bring along an assistant who can flash a reflector into the shadow side of your couple to fill in the effects of backlight. Reflectors are most effective when holding them below waist height and angling the overhead backlight back up into the subjects. Moving the reflector around and up and down will give you an idea of how much light it can reflect and where to position it for optimum results. A popular choice is the 72-inch gold and white reflector (two-sided). In bright situations, use the white reflector, so as not to overpower the natural light. In very soft light, use the gold reflector to increase the reflector's efficiency and to warm the scene.

Working at twilight or near twilight lets you take advantage of the low angle of the diffused skylight, which paints the subjects with soft light that fills faces beautifully. The trick is to not let the light intensity drop too much—otherwise, you will lose the ability to stop basic action at a reasonable ISO. Here, Marcus Bell photographed this late-afternoon bridal-party getaway at a relatively slow shutter speed and wide open aperture.

**Low-Angle Sunlight.** If the sun is low in the sky, you can use cross-lighting (split lighting) to get good modeling on your subject. Almost half of the face will be in shadow while the other half is highlighted. Turn your subject into the light so as not to create deep shadows along laugh lines and in eye sockets. If photographing a group, you must also position your subjects so that one person's head doesn't block the light of the person next to him or her.

There must be adequate fill-in from the shadow side of camera so that the shadows don't go dead. If using flash fill (see pages 77–79 for more on this) try to keep your flash output equal to or about a stop less than your daylight exposure. If using reflectors, you can bounce the direct sunlight back into the shadow side of the face(s) by carefully aiming the reflector.

It is also important to check the background while composing a portrait in direct sunlight. Since there is considerably more light than in a portrait made in the shade, the tendency is to use an average shutter speed like $\frac{1}{250}$ second with a smaller-than-usual aperture like f/11. Small apertures will sharpen the background and distract from your subject. Preview the depth of field to analyze the background. Use a faster shutter speed and wider lens aperture to minimize background effects in these situations. The faster shutter speeds may also negate the use of flash, so have reflectors at the ready.

**After Sunset.** As many of the great photographs in this book illustrate, the best time of day for making great pictures is just after the sun has set. At this time, the sky becomes a huge softbox and the effect of the lighting on your subjects is soft and even, with no harsh shadows.

There are, however, two problems with working with this great light. First, it's dim. You will need to use medium to fast ISOs combined with slow shutter speeds or vibration-reduction (VR) lenses, which allow you to handhold the camera at much slower shutter speeds than would normally be possible.

The second problem in working with this light is that twilight does not produce catchlights—white specular highlights in the eyes of the subjects. For this reason, most photographers augment the twilight with flash, either barebulb or softbox-mounted, to provide a twinkle in the eye. The flash can be up to two stops less in intensity than the skylight and still produce good eye fill-in and bright catchlights.

## Reflectors

You are at the mercy of nature when you are looking for a lighting location. Sometimes it is difficult to find the right type of light for your needs. Therefore, it is a good idea to carry along a portable light reflector. The size of the reflector should be fairly large; the larger it is, the more effective it will be. Portable Lite Discs, which are re-

### AUTO ISO FEATURE

Nikon and Canon DSLRs feature an Auto ISO setting. This allows the camera to automatically adjust the ISO upwards if the camera determines that proper exposure can not be achieved at the current exposure and ISO settings. Imagine you a working under fading light and need a specific shutter speed and aperture. To accommodate the lighting changes, you could have the camera adjust the ISO automatically to match the meter reading at that point. In Shutter Priority mode, if you wanted to work only within a certain range of apertures, you could use Auto ISO to keep your exposures correct when you move out of the range of possible apertures. If using this feature, it's a good idea to have the noise-reduction filters on in case the ISO climbs to ISO 1600 or 3200.

flectors made of fabric mounted on a flexible and collapsible circular or rectangular frame, come in a variety of diameters and are a very effective source of fill-in illumination. They are available from a number of manufacturers and come in silver (for maximum fill output),

This is a good example of the quality of light at or near sunset. The sun backlit the bride and groom, casting long, elegant shadows across the meadow grasses. Yet there was plenty of frontal fill to keep from silhouetting the couple. The fill was caused by the sun striking the clouds and sky opposite the setting sun at an angle close to the horizon—the twilight effect. Marcus Bell had to bias the exposure perfectly and do extensive burning-in in Photoshop to bring out the rich colors of the sky, yet hold detail and subtle tones in the grasses and nearby flowers.

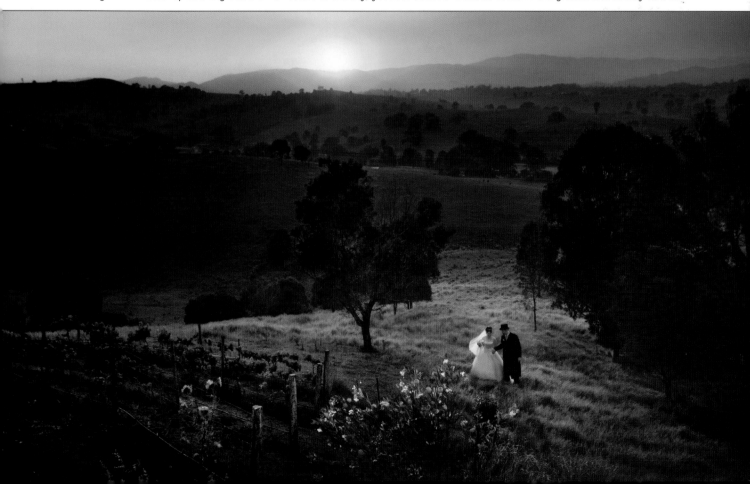

white, gold foil (for a warming fill light), and black (for subtractive effects).

**Positioning.** When the shadows produced by diffused light are harsh and deep, or even when you just want to add a little sparkle to the eyes of your subjects, you can use a large reflector—or even several reflectors. When doing so, it's helpful to have an assistant (or several light stands with clamps) so that you can precisely set the reflectors. Be sure to position them outside the frame area.

### *THE MAKING OF A REMARKABLE WEDDING PHOTOGRAPH*

Marc Weisberg is a perfectionist—something that is obvious when you see images like this. Here is how he made the shot.

"I've got to give props to Ken Sklute, my friend and mentor, for showing me how to group people," says Mark. "I always chat it up and get my clients relaxed and am able to make them laugh and forget that I am taking their photo." This image was shot late in the day, as Mark was losing sun. "The shadows are actually from my trusty Quantum flash, mounted with a Bogen quick release plate on a Bogen tripod at camera left," says Mark. "Instead of using a handheld meter, I used my more expensive 'light meter'—my Canon 1-D. I set it to manual and dialed in the exposure while looking at the meter scale through the viewfinder. I shot a Canon 'Polaroid' to make sure that my histogram was not clipping the shadows or highlights. Then, I set my Quantum flash one stop under, something I learned from Monte Zucker, and metered the flash output with my Sekonic L508 light meter. Pocket Wizards—I love these things—were used to trigger my Quantum flash."

To create this image, Mark used a 17–35mm f/2.8 L lens and shot in the JPEG Large mode ("That was then," he notes. "Everything is now shot RAW.") at ISO 200. The exposure was made at $^1/_{30}$ second at f/5.7. Off camera, his Quantum flash was set at approximately f/4.0. The flash was placed high, then angled down to rake across the group at an angle.

After the shoot, says Mark, "The saturation was selectively bumped up in Photoshop. A LucisArt filter was also used. Since this filter wreaks havoc on the skin, a mask was created so that I could selectively apply the effects to the dresses to bring out the delicate folds, and to the shoes and tuxedos to better bring out the highlights. I also used the LucisArt filter with a mask to bring out texture details in the walls, terra cotta tiles, and plants. "

The light in this pleasing bridal moment is exquisite. Direct sunlight bounces off a terra cotta wall onto the bride and, at the same time, produces a column of wonderful low-angle light. The photographer, Parker J. Pfister, knowing a good thing when he sees one, decided to photograph the light and not the bride, making her a well placed component in his superbly balanced design. Because the light was intense and he didn't want everything razor sharp, Parker opted for a $1/8{,}000$-second shutter speed at f/4.0 at ISO 200.

You will have to adjust the reflector several times to create the right amount of fill-in, being sure to observe lighting effects from the camera position. Be careful about bouncing light in from beneath your subjects. Lighting coming from below the eye–nose axis is generally unflattering. Try to "focus" your reflectors (this really requires an assistant), so that you are only filling the shadows that need filling in.

With highly reflective foil-type reflectors used close to the subjects, you can sometimes even overpower the ambient light.

**Natural Reflectors.** Many times nature provides its own fill-in light. Patches of sandy soil, light-colored shrubbery, or a nearby building may supply all the fill-in you'll need.

**Fuzzy Duenkel: Multi-Purpose Reflectors.** Fuzzy Duenkel uses a homemade reflector he calls the "Fuzzyflector." It is basically two double-sided, 4x4-foot rigid reflectors hinged in the middle so that the unit will stand up by itself. Because there are four separate sides, they can be used to produce four different levels of reflectivity. A Mylar surface provides a powerful reflector that can be aimed precisely to act as a key light in bright sun or an edge light from behind the subject. A spray-painted silver surface provides an efficient, color-balanced fill-in at close range. A white surface provides a softer fill and a black surface can be used for subtractive lighting. Because the reflector can be positioned in an L-shape to be freestanding, it can be used as a gobo and reflector simultaneously. Another way the reflector can be used is to position it beneath the subject's chin so that it reflects light up into the face. If using a tripod, one plane of the reflector can be rested or taped to the tripod, or an assistant can be used to precisely position the fill.

### Subtractive Lighting

**Too-Diffuse Light.** There are occasions when the light is so diffuse that it provides no modeling of the facial features. In other words, there is no dimension or direction to the light source. In these cases, you can place a black fill card (also called a gobo or flat) close to the subject to block light from reaching crucial areas. The effect of this is to subtract light from the side of the subject on which it's used, effectively creating a stronger lighting ratio. This difference in illumination will show depth and roundness better than will the flat overall light.

Another instance where black reflectors come in handy is when you have two equally strong light sources,

that strikes the subject then comes from either side and this becomes the dominant light source. This lighting effect is exactly like finding a porch or clearing to block the overhead light. There are two drawbacks to using an overhead gobo. First, you will need to have an assistant(s) along to hold the card in place over the subject. Second, using the overhead card lowers the overall light level, meaning that you may have to shoot at a slower shutter speed or wider lens aperture than anticipated.

### Diffusion Screens

**Spotty Light.** If you find an ideal location, but the light filtering through trees is a mixture of direct and diffused light (*i.e.,* spotty light), you can use a diffusion screen or scrim held between the subject and the light source to provide directional but diffused lighting. Scrims are available commercially and come in sizes up to 8x8 feet. These devices are made of translucent material on a semi-rigid frame, so they need to be held by an assistant (or assistants) to be effectively used.

**Direct Sunlight.** Scrims are also great when you want to photograph your subject in direct sunlight. Position the scrim between the light source and the subject to soften the available lighting. The closer the scrim is to the subject, the softer the lighting will be. As with window light, the Inverse Square Law (see page 12) applies to the light through a scrim. Light falls off fairly quickly once it passes through the scrim.

**Backlighting.** Another use for scrims is in combination with a reflector. With backlit subjects, the scrim can be held above and behind the subjects and a simple reflector used as fill-in for soft outdoor lighting. The soft backlight causes a highlight rim around the subject, while

each powerful enough to be the key light. This sometimes happens when using direct sun and a Mylar reflector. The black reflector used close to one side or the other of the subject will reduce the intensity of the lighting, providing a much-needed lighting ratio.

**Overhead Light.** If you find a nice location for your portrait but the light is too overhead in nature (creating dark eye sockets and unpleasant shadows under the nose and chin), you can use a gobo directly over the head of the subject to block the overhead illumination. The light

the reflector, used close to the subject, provides a low lighting ratio and beautifully soft, frontal lighting.

**Metering.** Using a scrim will lower the amount of light on the subject, so meter the scene with the device held in place. Since the light quantity will be lower on your subject than the background and the rest of the scene, the background may be somewhat overexposed—not necessarily an unflattering effect. To minimize the effect and prevent the background from completely washing out, choose a dark-to-medium-colored background. This type of diffusion works best with head-and-shoulders portraits, since the size of the diffuser can be much smaller and held much closer to the subject.

## Flash Techniques

**X-Sync Speeds.** All cameras with focal-plane shutters have an X-sync speed, the fastest speed at which you can fire the camera with a strobe attached. At speeds faster than the X-sync speed, only part of the frame will be exposed, because the shutter curtain will block off a portion of the frame. Modern SLRs and DSLRs have X-sync speeds up to $\frac{1}{500}$ second. ( *Note:* Cameras with lens shutters, like a Hasselblad, on the other hand, will sync with flash at any shutter speed.)

You can, of course, work at a shutter speed *slower* than the X-sync speed. This allows you to incorporate available light into the scene along with the flash. There is no limit to how slow a shutter speed you can use, but you may incur subject movement at very slow shutter speeds. In these situations, the sharply rendered subject will have an unnatural shadow around it, as if cut out from the background.

**Fill Light.** To measure and set the light output for a fill-in flash situation, begin by metering the scene. It is

Being an expert wedding photographer requires command of a wide array of disciplines, including architectural photography. In this beautiful image of the Basillica at San Juan Capistrano mission, Marc Weisberg planned the time of day so that the massive windows would entirely light the church. Careful control in post-production, using Photoshop and the LucisArt filter, helped bring diverse tonal areas into harmony.

best to use a handheld incident meter with the hemisphere pointed at the camera from the subject position. In this hypothetical example, the metered exposure is $\frac{1}{15}$ second at f/8. Now, with a flashmeter, meter the flash only. Your goal is for the output to be one stop less than the ambient exposure. Adjust the flash output or flash-to-subject distance until your flash reading is f/5.6. Set the camera to $\frac{1}{15}$ second at f/8. If using digital, a test exposure is a good idea.

*Barebulb Fill.* One of the most frequently used handheld flash units is the barebulb flash, which acts more like a large point source light than a small portable flash. Instead of a reflector, these units use an upright flash tube sealed in a plastic or acrylic housing for protection. Since there is no housing or reflector, barebulb flash provides 360-degree light coverage, meaning that you can use it with all of your wide-angle lenses. However, barebulb units produce a sharp, sparkly light, which is too harsh for almost every type of photography except outdoor portraits.

Light falloff is less than with other handheld units, making barebulb ideal for flash-fill—particularly outdoors. The trick is not to overpower the daylight.

Barebulb units are predominantly manual flash units, meaning that you must adjust their intensity by changing the flash-to-subject distance or by adjusting the flash output.

*Softbox Fill.* Other photographers like to soften their fill-flash. Robert Love, for example, uses a Lumedyne strobe in a 24-inch softbox. He triggers the strobe cordlessly with a radio remote control. He often uses his flash at a 45-degree angle to his subjects (for small groups) for a modeled fill-in. For larger groups, he uses the softbox next to the camera for more even coverage.

*TTL Fill.* Photographers shooting 35mm systems often prefer on-camera TTL flash. Many of these systems feature a mode that will adjust the flash output to the ambient-light exposure for balanced fill-flash. Many such systems also offer

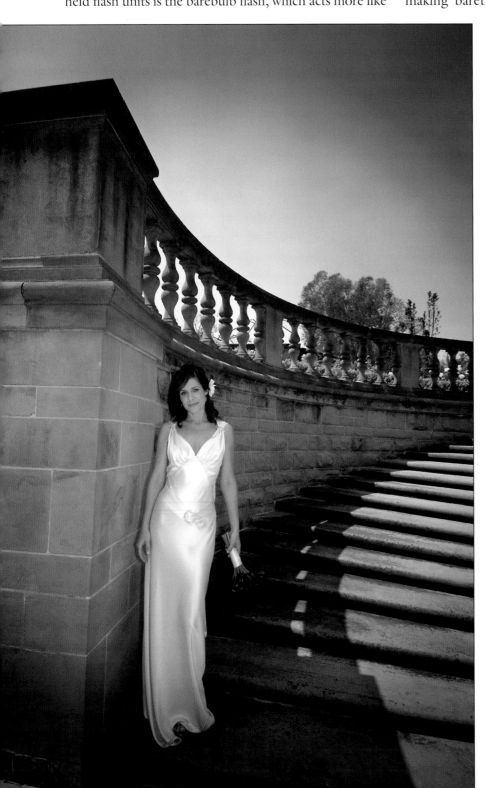

TTL-balanced fill flash is extremely accurate with today's DSLRs and dedicated flash systems. Cherie Steinberg Coté made this wonderful fashion portrait of a bride in a direct-sun situation, the bride being in shade. Her main lighting was Matrix-balanced fill flash with a Nikon D70 and SB-80 DX flash. These systems are so precise that you can set flash- or exposure-compensation in $\frac{1}{3}$-stop increments and the system will defy your imagination with its uncanny accuracy, allowing the photographer to concentrate on the composition and posing and not the nuts and bolts of on-location flash fill.

ABOVE—Strobe Slipper Plus shown with Pocket Wizard receiver mounted on PhotoFlex heavy-duty Swivel with PhotoFlex Adjustable Shoe Mount and Q39 X-small softbox. RIGHT—Don't think too hard about the direction of the main light in this stylized bridal portrait; it has been altered by the introduction of a Strobe Slipper used to camera left as a soft key light. The strong shadows produced by direct sunlight still exist, but would have been a disaster had that light been the primary light source. The exposure was $^1/_{250}$ second at f/16, one stop greater than the daylight exposure for bright sunlight. Photograph by Bruce Dorn.

flash-output compensation that allows you to dial in full- or fractional-stop output changes for the desired ratio of ambient-to-fill illumination. They are marvelous systems and, more importantly, they are reliable and predictable. Some of these systems also allow you to remove the flash from the camera with a TTL remote cord.

Some of the latest digital SLRs and TTL flash systems allow you to set up remote flash units in groups, all keyed to the flash on the camera. Nikon's system of dedicated TTL flash units use an in-camera Flash Commander mode, where you can use the on-camera flash to trigger an array or several arrays of dedicated flash units. This is ideal for wedding receptions—provided you have a team of assistants to hold the mobile, cordless flash units (SB-800, SB-80, or SB-60 Speedlights). The individual satellite strobes are controlled from the camera's Flash Commander mode (DX2s and D200). You could, for instance, photograph a wedding group with four synced flashes remotely fired from the camera location, all producing the desired output for the predetermined flash-to-daylight ratio. It's an amazing system, which

many commercial photographers are now using for on-site multiple-light assignments.

*Flash-Fill with Studio Strobes.* If you are using a studio-type strobe, the flash output can be regulated by adjusting the flash unit's power settings, which are usually fractional—½, ¼, ⅛, and so forth. If, for example, the daylight exposure is ¹/₆₀ second at f/8, you could set your flash output so that the flash exposure is f/5.6 or less to create good flash-fill illumination.

**Flash Key.** Sometimes, you may want to use your flash as a key light that overrides the ambient daylight. When doing so, it is best if the flash can be removed from

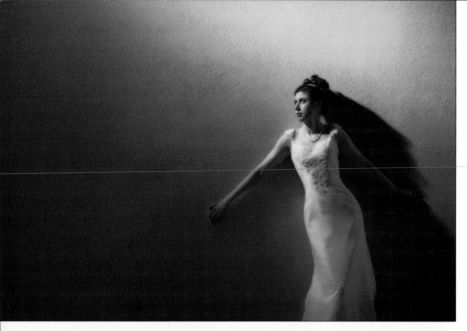

*LEFT*—"In this example, the bride and I were finishing up a session late in the evening when I happened to see this wonderful directional beam of light created by streetlights. Upon seeing this, I persuaded the bride to take a few shots in this spot," says Kevin Jairaj. "I really wanted to try something a bit more dramatic and edgy to match the ambiance of the location." *BOTTOM*— "This image, from a wedding I recently photographed in Cancun, is an example of how I used directional window light to accentuate the shadow detail in the wedding dress," says Kevin Jairaj. "My shooting angle allowed the window light to skim across the dress beautifully, making for a more dimensional and dynamic image instead of a flatly lit one. In the finished image, you can really see the detail and elegance of the dress showcased by the way the light from the window is hitting the scene."

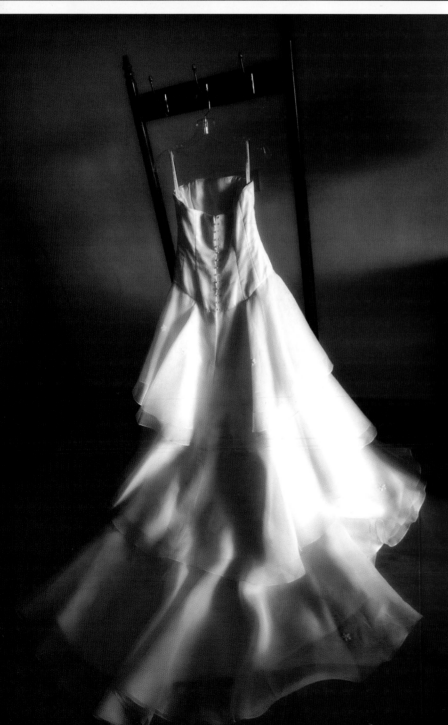

the camera and positioned above and to one side of the subject. This will more closely imitate nature's light, which always comes from above and never head-on. Moving the flash to the side will improve the modeling qualities of the light and show more roundness in the face.

When adding flash as the key light, it is important to remember that you are balancing two light sources in one scene. The ambient light exposure will dictate the exposure on the background and the subjects. The flash exposure only affects the subjects. Knowing this, you can use the difference between the ambient and flash exposures to darken the background and enhance the colors in it. However, it is unwise to override the ambient light exposure by more than two f-stops. This will cause a spotlight effect that will make the portrait appear as if it were shot at night.

Remember that electronic flash falls off in intensity rather quickly, so be sure to take your meter readings from the center of the subject area (and, with group portraits, from either end—just to be on the safe side). With a small group of three or four people you can get away with moving the strobe away from the camera to get better modeling—but not with larger groups, as the falloff is too great. You can, however, add a second flash of equal intensity and distance on the opposite side of

Mark Cafiero minimized a potentially distracting background by shooting at his zoom lens's widest aperture of f/3.5, which blended the highlights and shadows into an out-of-focus jumble of tones. This lets the viewer focus solely on the bride. He also used out-of-focus foreground elements to isolate the bride.

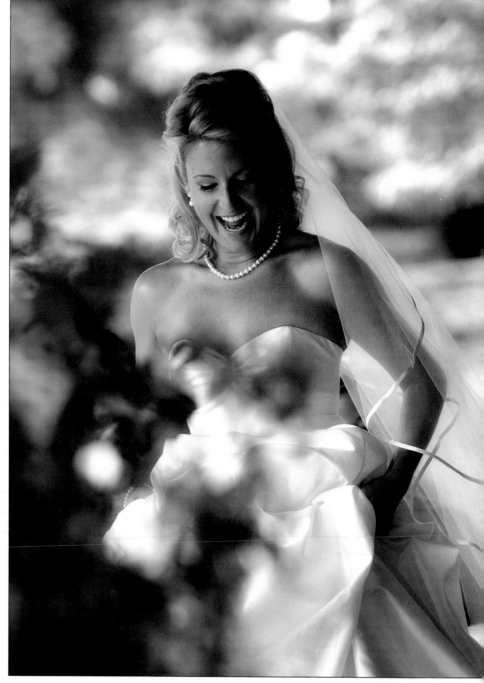

the camera to help widen the light. If using two light sources, be sure to measure both flashes simultaneously for an accurate reading.

*Flash Key on Overcast Days.* When the flash exposure and the daylight exposure are identical, the effect is like creating your own sunlight. This works particularly well on overcast days when using barebulb flash, which is a point-light source like the sun. Position the flash to the right or left of the subject and elevate it for better modeling. If you want to accentuate the lighting pattern and darken the background, increase the flash output to ½ to one stop greater than the daylight exposure and expose for the flash exposure. Do not underexpose your background by more than a stop, however, or you will produce an unnatural nighttime effect. Many times, this technique will allow you to shoot out in open shade without fear of creating shadows that hollow the eye sockets. The overhead nature of the diffused daylight will be overridden by the directional flash, which creates its own lighting pattern. To further refine the look, you can warm up the flash by placing a warming gel over the barebulb flash's clear shield. The gel will warm the facial lighting, but not the rest of the scene.

*Flash Key with Direct Sun.* If you are forced to shoot in direct sunlight (the background or location may be irresistible) position your subject with the sun behind them and use flash to create a frontal lighting pattern. The flash should be set to produce the same exposure as the daylight. The daylight will act like a background light and the flash, set to the same exposure, will act like a key light. Use the flash in a reflector or diffuser of some type to focus the light. If your exposure is 1/500 second at f/8, for example, your flash would be set to produce an f/8 on the subject. Position the flash to either side of the subject and elevate it to produce good facial modeling. An assistant or light stand will be called for in this lighting setup. You may want to warm the flash output with a warming gel over the flash reflector. This is when DSLRs are handy.

## Controlling the Background

**Depth of Field and Diffusion.** For a portrait made in the shade, the best type of background is monochromatic. If the background is all the same color, the subjects

will stand out from it. Problems arise when there are patches of sunlight in the background. These light patches can be minimized by shooting at wide apertures. The shallow depth of field blurs the background so that light and dark tones merge. You can also use a diffuser over the camera lens to give your portrait an overall misty feeling. When you do so, you will also be minimizing a distracting background.

**Retouching.** Another way to minimize a distracting background is in retouching and printing. By burning-in or diffusing the background you make it darker, softer, or otherwise less noticeable. This technique is really simple in Photoshop, since it's fairly easy to select the subjects, invert the selection so that the background is selected, and perform all sorts of maneuvers on it—from diffusion and color correction to density correction. You can also add a transparent vignette of any color to visually subdue the background.

**Subject-to-Background Distance.** Some photographers, when working outdoors, prefer to place more space between group members to allow the background to become better integrated into the overall design.

**Tonal Separation.** One thing you must watch for outdoors is subject separation from the background. A dark-haired subject against a dark-green forest background will not separate, creating a tonal merger. Adding a background reflector to kick some light onto the hair would be a logical solution to such a problem.

### Cool Skin Tones

A problem you may encounter is cool coloration in portraits taken in shade. If your subject is standing in a grove of trees surrounded by foliage, there is a good chance green will be reflected into the skin tones. Just as often, the foliage surrounding your subject in shade will reflect the cyan of an open blue sky.

In order to correct green or cyan coloration, you must first observe it. Your eyes will become accustomed to seeing the off-color rendering, so you will need to study the faces carefully—especially the coloration of the shadow areas of the face. If the color of the light is neutral, you will see gray in the shadows. If not, you will see either green or cyan.

Marc Weisberg, working in subdued light aboard a moving yacht, decided not to chance it—he fired an off-camera flash as a key light to overpower the available light. His flash exposure was about one stop hotter than the daylight exposure, darkening the background as if it were dusk. The off-camera flash was held high and to camera left to effectively model the couple, creating a flattering lighting in an otherwise tricky lighting situation.

Sometimes a messy background can be minimized by grouping the bridal party tightly in a cluster and cropping in close to minimize the amount of the objectionable area that is visible in the image. British bridal parties can be rather cornball—an effect sometimes initiated by the photographer. Photograph by Dennis Orchard.

Before digital capture, if you had to correct this coloration, you would use color-compensating (CC) filters over the lens. These are gelatin filters that fit in a filter holder. To correct the color shift, you would use the complimentary filter to neutralize the color balance of the light. With digital you only need to perform a custom white balance or use one of the camera's preprogrammed white balance settings, like "open shade."

Those who use the ExpoDisc swear by its accuracy in these kinds of situations. By correcting the white balance, there is no need to color-correct the scene with filters.

There are times, however, when you want the light to be warm, not neutral. In these situations, you can use a gold-foil reflector to bounce warm light into the faces. The reflector does not change the color of the foliage or background, just the skin tones.

# 7. THE WEDDING DAY: PREPARATION AND KEY MOMENTS

### Preparation

The better prepared the photographer is, the better the pictures will be. It's no different than the sports photographer knowing the status of every player and the tendencies of each team before the game. When prepared, the photographer can predict a certain amount of the action—or at least the probability of such action. To do this, the wedding photographer must know the clients, and must know the detailed plans for the day, both the wedding and reception. It also helps to put in the time. Arriving early and leaving late is one way to be assured you won't miss great shots.

Visiting each venue is an excellent way for you to prepare for the day. Another good practice is to schedule an engagement portrait. This has become a classic element of modern-day wedding coverage. The portrait can be made virtually anywhere, but it allows the couple time to get used to the working methods of the photographer, so that on the wedding day they are accustomed to the photographer's rhythms and style of shooting. The experience also helps the threesome get to know each other better, so the photographer doesn't seem like an outsider at the wedding.

### Meeting With the Bride and Groom

Arrange a meeting with the couple at least one month before the wedding. Use this time to take notes, formulate detailed plans, and get to know the couple in a relaxed setting. This initial meeting also gives the bride and groom a chance to ask any questions of you they may

Meeting with the bride and groom beforehand lets the photographer gain the couple's complete trust so that they are more like friends than clients on the wedding day. Charles Maring, shown here, laughingly coaxes his couple into a great shot while crossing a busy Manhattan street. Photo by Jennifer Maring.

have. It is also the time when the couple can tell you about any special pictures they want you to make, as well as let you know of any important guests that will be coming from out of town. Make notes of all the names—the parents, the bridesmaids, the groomsmen, the best man and maid of honor—so that you can address each person by name.

It will be time well spent and allows you a month after the meeting to check out the locations, introduce yourself to the people at the various venues (including the minister, priest, or rabbi), and get back to the couple if there are any problems or difficulties. Note the color scheme the couple will be using, and get detailed information from the florist, the caterer or banquet manager, the limo driver, the band, and so on. You may find out interesting details that will affect your timetable or how you make certain shots. Australian photographer Martin Schembri also uses this time to see and study the gown in a fashion and design sense; he uses these mental notes as preparation for the album design.

When you meet with the clergyman, make sure you ask about any special customs or traditions that will be part of the ceremony. At many religious ceremonies

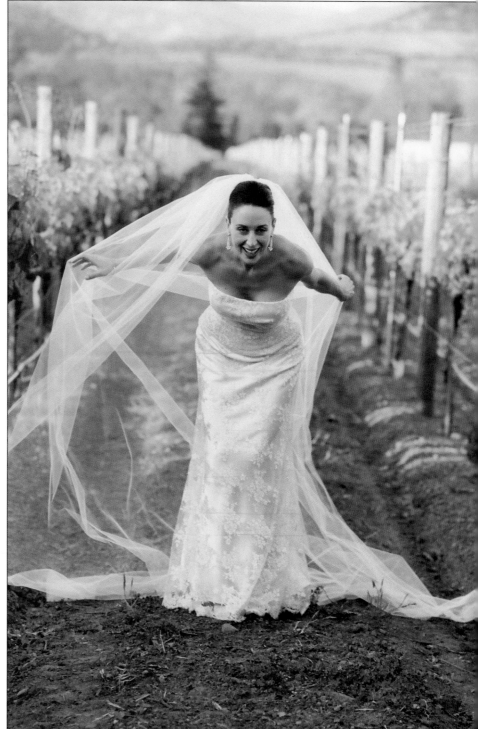

The fact that Alicia and Brook Todd work as a team allows them to split time between the bride and groom before the ceremony. The groom, unfortunately, usually gets the short end of the photographic stick on the wedding day, so a winning portrait of him will enhance the album and add a great deal to your coverage of the wedding. The bride will also greatly appreciate your efforts.

you can move about and even use flash, but it should really be avoided, in favor of a more discreet, available-light approach. Besides, available light will provide a more intimate feeling. At some churches you may only be able to take photographs from the back, in others you may be offered the chance to go into a gallery, choir loft, or balcony. Also, be prepared not to be allowed to make pictures at all during the ceremony. Being completely invisible during the ceremony is actually a positive. You may still be able to make shots with long lenses from a discreet position, but to interrupt the ceremony will take attention away from this most significant moment.

You should know how long it takes to drive from the bride's home to the ceremony. Inform the bride that you will arrive at least an hour to 45 minutes before they leave. You should arrive at church at about the same time as or a little before the groom, who should arrive about

a half-hour before the ceremony. At that time you can make portraits of the groom and his groomsmen. Bridesmaids will arrive at about the same time. Additionally, you need to determine approximately how long the ceremony will last.

### Engagement Portrait

The engagement portrait can be a significant part of forging a good relationship with the bride and groom. After a couple books a wedding, wedding photographers Alisha and Brook Todd call the couple once a month to check in. When the contract goes out, they send a bottle of Dom Perignon with a handwritten note. They soon schedule the engagement portrait, which is a stylized romantic portrait of the couple made prior to the wedding day at the location of the couple's choice. Once the wedding day arrives, they have spent quality time with the

couple and they've been in touch numerous times by phone and in person. "We really try to establish a relationship first," says Brook. "It's how we do business."

Since this one image is so important to establishing a good rapport between photographer and couple, many photographers include the engagement portrait as part of their basic coverage. In other words, they don't charge extra for it.

Many couples use the engagement portrait for newspaper announcements. Often, the photographer will also produce a set of note cards using the engagement portrait as a cover. The couple can then use these as thank-you notes after they return from the honeymoon. These

Joe Photo made this impressive engagement portrait of the bride and groom on horseback with a Nikon D1X and Nikkor 80–200mm f/2.8 lens at $^1/_{500}$ second at f/2.8. There is no way this kind of shot could have been made on the wedding day. A separate engagement portrait session is necessary, but it only builds rapport between photographer and client.

## ASSISTANTS

While the contemporary wedding photographer may possess extraordinary powers of observation and razor-sharp timing and reflexes, he or she may still miss the moment by virtue of someone getting in the way or one of the principals in the scene turning away at the last second.

Assistants can run interference for you, downloading memory cards so that they can be reused, burning CD backups on the laptop, organizing guests for group shots, helping you by taking flash readings and predetermining exposure, taping light stands and cords securely with duct tape and 1000 other chores. They can survey your backgrounds looking for unwanted elements and they can be a moveable light stand, holding your secondary flash for back or side-lighting.

An assistant should be trained in your brand of photography so that he or she knows how to best help you. A good assistant will be able to anticipate your needs and prepare you for upcoming shots. An assistant should be completely familiar with your "game plan" and know everything that you know about the details of the day.

Assistants can be invaluable in 1000 different ways, including helping you create a "floral arrangement" of bridesmaids. Photograph by Dan Doke.

can be delivered to the bride's mother before the wedding or while the couple is away.

### Pre-Ceremony Coverage

Usually, the actual wedding photography begins at the bride's home as she is getting ready. Some of the most endearing and genuine photographs of the day can be made at this time. Be wary, however, as emotions are high. If chaos reigns in the bedrooms, don't be afraid to step back and get out of the way. By being a good observer and staying out of the way, you are sure to get some great shots, because no one has time to worry about you; it's like you're invisible.

It is important to avoid photographic clichés and, instead, be alert for the unexpected moments. There are all too many photos of the bride looking into the mirror as she gets ready. One of the unique fascinations brides have is with their shoes and with the act of putting them on. You might also create shots featuring the maid of honor or the bride's mother, both of whom are integral to the bride's preparations. Since the ceilings of most homes are quite low and upstairs bedrooms often have multiple windows, you can usually expose these images by bounce flash and/or available light.

It is important not to wear out your welcome at the bride's home. Although you should arrive an hour or more earlier (before the bride is due to arrive at the ceremony), you should be prepared to leave and arrive at the ceremony at the time the groom arrives. Photographing him before the ceremony will also produce some won-

Avoid cliché images of the bride getting ready by focusing on the emotion and mood. Here, Dan Doke has captured a beautiful and self-assured bride putting the finishing touches on her own lip gloss. The significant detail of the shot is not the act, but the look of confidence and self-esteem (as well as a little bit of urgency) in her eyes. That's what makes this shot great.

A poignant moment is registered on the bride's face as she prepares for the ceremony with her maid of honor. The photographer, Marcus Bell, chose to let everything but the bride's eyes fall out of focus so he could concentrate on the intensity of her emotion, which seems to register both joy and sadness—not an uncommon emotion in brides-to-be. Using an 85mm f/1.4 lens, Marcus chose to shoot at f/1.4 to diminish any depth of field so the emphasis could be on the bride's eyes.

derful shots, and it is also a great time to create a formal portrait of the groom and his groomsmen. It is also a good time to produce some casual portraits. Although he won't admit it, the groom's emotions are running high and it usually leads to some good-natured bantering between the groom and his friends.

If you have an assistant or are shooting the wedding as a team, have your counterpart be prepared to handle the groom at the ceremony, while you stay with the bride at her home. You may want to get a shot of her getting into the limo—an exercise in physics. Her dad saying goodbye is always a good shot, as well.

This is also a good time to capture many of the details of the wedding attire. The flowers being delivered at the bride's home, for instance, can make an interesting still life, as can many other accessories for the wedding-day attire. The groom's boutonniere is another stylish image that will enhance the album.

### Photographing the Ceremony

Before the guests arrive is a good time to create an overall view of the church, as no two weddings ever call for the same exact decorations. If there is an overhead vantage point, like a choir loft, this is a good place to set up a tripod and make a long exposure with good depth of field so that everything in the image is sharp. This kind of record shot will be important to the historic aspects of the wedding album. This is also a great place to shoot from as the bride enters the church with the pews all filled with people. ( *Note:* You may decide to let an assistant get this shot.)

When the bride arrives at the ceremony and is helped out of the car, sometimes by her dad, there are ample opportunities for good pictures. It isn't necessary to choreograph the event—there will already be plenty of emotion between the bride and her father. Just be ready and you will be rewarded with some priceless images.

*LEFT*—When the bride arrives for the wedding, every step she takes is a measured response to her appearance and well being. This bride exiting the limo looks down at her shoes to make sure each step she takes is secure. Is it, perhaps, a metaphor for marriage? Photograph by Greg Gibson. *RIGHT*—This is the "*People* magazine" moment, when the beautiful bride and handsome groom exit the church brimming with confidence and happiness. Sometimes, the photographer will luck out and be able to use the TV/videographer's lights. Photographer Mauricio Donelli also fired a fill flash to be sure of the exposure. This is the shot you don't want to miss. On a big wedding, you may even want to ensure it by having a second shooter on hand.

When the bridesmaids, flower girls, ring bearers, mother of the bride, and the bride herself (sometimes with her dad) come up the aisle, you should be positioned at the entrance of the church so that the subjects are walking toward you. If you are part of a team, have another photographer positioned at another location so that you can get multiple viewpoints of this processional.

Once the ceremony begins, be as discreet and invisible as possible, shooting from an inconspicuous or even hidden vantage point and working by available light. Often a tripod will be necessary as exposures, even with a fast ISO setting, may be on the long side, like $^1\!/_{15}$ second. Weddings are solemn occasions and the ceremony itself will present many emotion-filled moments. Keep in mind that the ceremony is more important than the pho-

tographer or even the pictures, so prioritize the event by being as discreet as possible. Be alert for surprises and pay special attention to the children who will do the most amazing things when immersed in a formalized ritual like a wedding.

For the ceremony, try to position yourself so that you can see the faces of the bride and groom, particularly the bride's face. This will usually place you behind the ceremony or off to the side. This is when fast film (or high ISO settings) and fast, long lenses are needed, since you will almost surely be beyond the range of the frequently used 80–200mm zoom. Look for the tenderness between the couple and the approving expressions of the best man and maid of honor. Too many times the photographer positions him- or herself in the congregation. The

*LEFT*—As the bride and her maids arrived for the event, Greg Gibson captured the uphill march full of gaiety and fun. Small moments within the day abound and are plentiful for the observant photographer. *RIGHT*—This is a standard exchanging-the-vows image shot from the back of the church. What makes it different is the little boy peering around the groom to get a closer look at the action. Photograph by Marcus Bell.

minister or rabbi will not be purchasing any photographs, so it is the faces of the bride and groom that you will want to see.

If you are behind the ceremony, you cannot immediately bolt to the back of the church or synagogue to capture the bride and groom walking up the aisle as man and wife. This is when it is important to have a second shooter, who can be perfectly positioned to capture the bride and groom and all of the joy on their faces as they exit for the first time as man and wife.

Be aware of changing light. Inside the church, it will be at least three to four stops darker than in the vestibule. As the couple emerges, the light will change drastically and quickly. Know your exposures beforehand and anticipate the change in light levels. Many a gorgeous shot has been ruined by the photographer not changing exposure settings to compensate for the increased light levels.

When photographing the bride and groom leaving the church, include the door frame as a reference. If photographing from the side, try to position yourself on the bride's side, so she is nearest the camera. Because of diminishing perspective, if the groom is in the foreground, the bride will look even smaller than she might be in reality.

If there is to be a rice, confetti, or bubble toss, these are best photographed with a wide-angle lens from close up, so that you can see not only the bride and groom, but the confetti (or rice, or bubbles) and the faces of the people in the crowd. It's a good idea to choreograph this shot with the crowd so they throw their confetti on your signal, usually as the couple reaches the steps. Be sure to tell them to throw the stuff above the head height of the bride and groom so that it descends into your photograph. While choreographed, the shot will look unstaged

TOP—Be ready for those fleeting moments when the wedding party enters or leaves the church. This little scene no doubt entertained the attendees, but look at the dejected expression of the little girl on the left. Photograph by Mark Nixon. **BOTTOM**—Using a long lens (80–200mm) and a fast shutter speed (1/250 second) allowed the photographer to concentrate on the expressions and interaction between the women. A telephoto removes the photographer from the scene and eliminates the need for the participants to perform for the camera, producing a spontaneous image. Photograph by DeEtte Sallee.

as the bride and groom will be unaware of your planning and will undoubtedly flinch when they see the rice/confetti in the air. This type of scene is best shot with two photographers.

Many photographers who love photographing weddings have told me that they get overwhelmed sometimes by the emotion of the wedding event. The best way to keep your emotions in check is to focus your attention on every detail of the event. Immersing yourself in the flow of the wedding and its details will help you to be more objective and put you in touch with the many subtleties of the day.

### Photographing the Reception

Since the bride and groom are so preoccupied at the reception, they actually get to see very little of it and therefore depend on your pictures to provide memories. You will want to photograph as many of the details and events of the reception as possible.

Be sure to make several good overviews of the decorated room. This should be done just before the guests enter, when the candles on the tables are lit and everything looks perfect. Be sure to photograph the details—table bouquets, place settings, name cards, etc.. These things help enrich the finished wedding album.

The photo opportunities at the reception are endless. As the reception goes on and guests relax, the opportunities for great pictures will increase. Be aware of the bride and groom all the time, as they are the central players. Fast lenses and a higher-than-normal ISO settings will help you to work unobserved.

Be prepared for the scheduled events at the reception—the bouquet toss, removing the garter, the toasts, the first dance, and so on. If you have done sufficient preparation you will know where and when each of these events will take place and you'll be prepared to light and photograph each one. Often, the reception is best lit with a number of corner-mounted umbrellas, triggered by your on-camera flash. That way, anything within the perimeter of your lights can be photographed by strobe. Be certain you meter various areas within your lighting perimeter so that you know what your exposure will be everywhere within the reception area.

The reception calls upon all of your skills and instincts—and things happen quickly. Don't get caught with an important event coming up and only two frames left in the camera. Use two camera bodies and always have plenty of exposures available, even if it means changing CF cards before you're ready to.

People are having a great time, so be cautious about intruding upon events. Observe the flow of the reception and carefully choose your vantage point for each shot. Be sure to coordinate your efforts with the wedding planner or banquet manager. He or she can run interference for you as well as cue you when certain events are about to

*LEFT*—Be aware of fleeting events, such as this moment of joy and wonder as the bride and groom observed a happening at the reception. Charles Maring made the image with a Canon EOS 1D Mark II and 200mm lens at $^1/_{30}$ second at f/2.8 at ISO 1250. The couple never knew that he was taking their picture. *BELOW*—Jeff Kolodny does a masterful job of photographing the venue prior to the reception. Here, he used a Nikon D200 and 10.5mm fisheye lens. With the camera tripod-mounted, he photographed the scene at ISO 100 for 30 seconds at f/22, to extend the depth of field to cover the entire room. His white balance was set to Auto, but he warmed the scene in RAW file processing. He also lowered the contrast to better deal with the blown-out windows at the far end of the room.

*FACING PAGE*—Charles Maring, knowing the venue, chose an overhead viewpoint from which to photograph the dance floor. Shooting into the tables, he could record not only the bride dancing, but the reaction of those who were seated for the reception. This is a good example of how doing advance scouting can reveal countless picture advantages. Charles used an 85mm f/1.2 lens and his EOS 1D Mark II at ISO 500; the exposure was made at ¹/₆₀ second at f/1.2. *RIGHT*—Australian weddings are often a bit different than those in the U.S. The bride and groom usually get married early in the day, retire to a local watering hole during the afternoon, then return to a reception in the early evening. That time in the middle of the day gives the photographer a chance to create lots of images while the couple and wedding party are at their favorite pub. Here, Yervant used the available light of the place, but keyed the image with a handheld video light. Yervant's preference is a Lowel i-light (non-dimmable), a handheld video light with a high intensity reflector and prismatic glass that gives an even flood pattern or a uniform spot. The light can be handheld by the photographer or an assistant and feathered to create a perfect key lighting at close range.

occur, often not letting the event begin until you are ready.

Photojournalists know how to get the shot without alerting the people being photographed. Some photographers walk around the reception with their camera held low, but with both hands in position on the camera so that they can instantly raise the camera to eye level, frame the image, and shoot. Others use a wide-angle lens set to wide-area autofocus in one of the camera's autoexposure modes. With the camera at waist or hip height, the photographer will then wander around the reception, mingling with the guests. When a shot seems to be taking place, they will aim the camera up toward the people's faces and fire, never even looking through the viewfinder.

The final shot of the day will be the couple leaving the reception, which is usually a memorable photo. Like so many events at the reception, planned or spontaneous, it is best to have as many angles of the event as possible, which is why so many wedding photographers work with a shooting partner or assistants.

**Lighting.** *Pole Lighting.* Many photographers employ an assistant at the reception to walk around with a bare-bulb flash attached to a monopod. The strobe is slaved and can be triggered by a radio transmitter on the camera or by an on-camera flash. The pole light can be positioned anywhere near the subjects and can be set to overpower the on-camera flash by one f-stop so that it becomes a main light.

Your assistant should be well versed in the types of lighting you like to create with this rig. For instance, if he or she is at a 45-degree angle to the subject and the light is held about four feet over the subjects' head height, the resulting lighting will resemble Rembrandt-style side lighting. If you prefer to backlight your subjects, then your assistant can position himself behind the group to create a rim-lighting effect.

When taking an exposure, read the room light first and set the flash output to the same aperture as the ex-

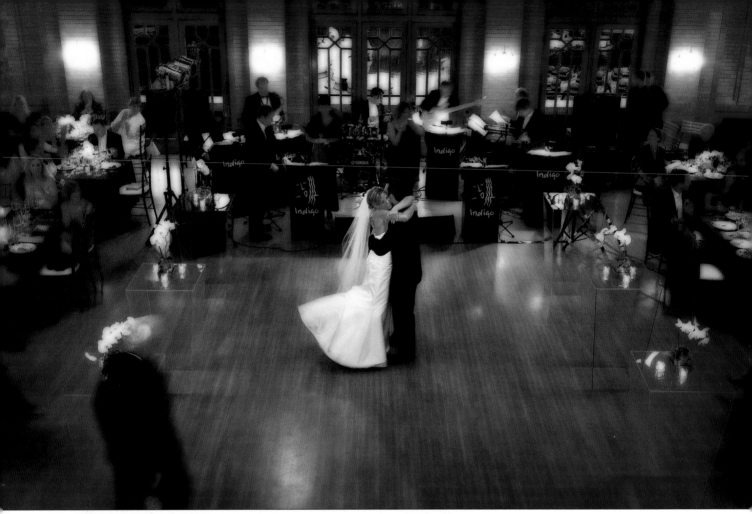

This photo of the couple's first dance is amazing. Joe Photo made it at $1/8$ second at f/2.8, then enhanced the image in Photoshop with filters and Gaussian Blur. As you can see, there is some blur on the people moving in the scene. The key to using such low light is bracing the camera, in this case on a balcony railing, and waiting until the participants are either at the apex of action, which is very still, or until they hold the moment.

isting light exposure. That way the flash will not overpower the room lights.

*Videographer's Lighting.* If a wedding video is being produced, you will have the luxury of the videographer's rigging and lighting the reception hall with hot lights—usually quartz halogen lights, which are very bright and will make your reception photography much easier. The only problem is that you will have to adjust your white balance to compensate for the change in color temperature of the quartz lights.

*Handheld Video Lights.* Many of the Australian wedding photographers, like David Williams and Yervant, use handheld battery-powered video lights as accent or fill lights. Williams uses a low-wattage light, around 15–20 watts, for just a little light to add mood or color or accent to a scene. Yervant uses a 100-watt Lowel Light that will overpower room light depending on the distance at which it is used.

The effects are quite beautiful and, because you can change your white balance on the fly, the color balance will be superb and match the room lighting. Sometimes the photographers will hold the light themselves, sometimes they'll give it to an assistant if a certain lighting effect is desired.

One of the great things about these lights is that you can see the effect you will get in the viewfinder. Also, since the light units are small and maneuverable, you can feather them quite easily, using the more dynamic edge of the light.

### Rings

The bride and groom usually love their new rings and will want a close-up shot that includes them. This is a great detail image in the album. You can use any attractive pose, but remember that hands are difficult to pose. If you want a really close-up image of the rings, you will

need a macro lens and you will probably have to light the scene with flash or video light, unless you make the shot outdoors, in strong window light, or using strong available room light.

### The Cake-Cutting

One of the key shots at the reception is the cutting of the wedding cake. This is often a good opportunity to make an overhead group shot of the crowd surrounding the bride and groom. Bring along a stepladder for these types of shots. A second shooter is a good idea in these situations so that details and priceless moments won't be missed. Also, be sure to get a still life of the cake before it is cut. Both the couple and the baker/caterer will want to see a beautiful shot of their creation.

### The First Dance

The first dance is an important moment in the reception and one that you will want to document thoroughly. Don't turn it into a cliché. Just observe, and try to shoot it with multiple shooters so as not to miss the good expressions. You will be rewarded with emotion-filled, joyful moments.

### The Bouquet Toss

This is one of the more memorable shots at any wedding reception. Whether you're a photojournalist or traditionalist, this shot always looks best when it's spontaneous. You need plenty of depth of field, which almost dictates a wide-angle lens. You'll want to show not only the bride but also the expectant faces in the background, which usually necessitates two shooters. Although you can use available light, the shot is usually best done with two flashes—one on the bride and one on the ladies hoping to catch for the bouquet. Your timing has to be excellent as the bride will often "fake out" the group (and you), just for laughs. Try to get the bouquet as it leaves the bride's hands.

### Table Shots

Table shots are the bane of every wedding photographer's day. They rarely turn out well, are often never ordered, and are tedious to make. If your couple absolutely wants table shots, ask them to accompany you from table to table. They can greet their guests and it will make the posing quick and painless. You might also consider talking the couple into one big group shot that encompasses nearly everyone at the reception. These are always fun to participate in and to photograph.

### Little Ones

One of the best opportunities for great wedding pictures comes from spending some time with the smallest attendees and attendants: the flower girls and ring bearers. They are thrilled with the pageantry of the wedding day and their involvement often offers a multitude of picture opportunities.

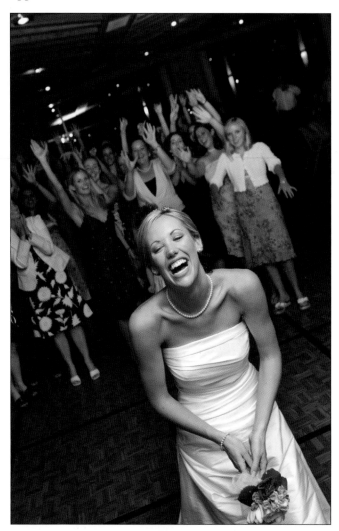

The bride's bouquet toss is often filled with trickery and deceit on the part of the bride. Here, Mark Cafeiro captured this lovely bride in the middle of a belly laugh, apparently at her maidens' expense. Mark fired a bounce flash at the bride and relied on enough ambient light to light the waiting young brides-to-be. Mark made the shot with a Canon EOS 20D and 24mm lens at $1/50$ second at f/3.5 at ISO 400 with the bounce flash held slightly to camera right. Mark was standing on a chair to get above the scene for a better overall view.

# 8. THE FORMALS

Even in a photojournalistic wedding, up to 15 percent of the coverage may be groups and formals. This is simply because gatherings of this type bring together many people from the couple's lives that may never be assembled together again. That makes it imperative that group pictures be made to commemorate the occasion.

Also, most brides and families want to have a formal remembrance of the day, which may include the formal portraits of bride alone, groom alone, bride and groom together, bride and bridesmaids, groom and groomsmen, full wedding party, family of the bride, family of the groom, and so on. These images are something that the

BELOW—This group shot of the bridal party, compared to those of the past, is decidedly different. JB Sallee made the image with a Nikon D2X and 17mm f/2.8 lens. The exposure was $^1/_{250}$ second at f/2.8 at ISO 100. The lighting was available daylight. *FACING PAGE*—Al Gordon waited until the perfect moment at sunset to create this fun wedding party photo. Note that both the flash and ambient exposures are perfect. As if to increase the difficulty factor, he had the group splash with their feet so he could freeze the water with his flash. Also note his elevated vantage point and the perfect arrangement of the group. For all of its control, there is still spontaneity and joy in the image.

ABOVE—The photojournalistic point of view opens up many creative doors to formal portraits. Here, Greg Gibson used his EF 15mm f/2.8 lens on a Canon EOS 5D at ISO 3200 to create this view of the event. Notice that, because the lens is a fisheye and positioned expertly, you get a real sense of the venue, the couple, the bridal party, and the elegance of the day. Working with the RAW file, Gibson made this image file emulate the look of Tri-X film souped in Diafine or Acufine developer. *FACING PAGE*—While good posing for men usually means turning the shoulders at an angle to the camera, it is not always essential because physical size and width are strong male attributes. Here, natural posing and split lighting from nearby bay windows were used to produce a strong portrait of the groom. Notice how the tilt of the pose (because he is leaning on the banister) creates a strong diagonal running through the composition. Photograph by Joe Photo.

couple expects the photographer to make on the day of their wedding.

As you will see, however, formals and groups done by a contemporary wedding photojournalist differ greatly from the stiff "boy–girl, boy–girl" posing of the traditional wedding photographer, where everyone is looking directly into the camera lens. A lot of imagination goes into the making of these formals and many times, one cannot really tell that the photographer staged the moment. The photographer preserves the naturalness and spontaneity in keeping with the photojournalistic spirit.

Wedding photojournalists draw a great deal from editorial and advertising photography. In fact, many of the more famous wedding photojournalists also do work for bridal magazines, illustrating new bridal fashions and

trends. The fact that these pictures are posed and highly controlled doesn't seem to diminish their popularity among brides. The images have a certain style and elegance, regardless of whether or not the subjects are looking into the camera.

The rigors of formal posing will not be seen in these photos. But knowledge of posing fundamentals will increase the likelihood of capturing people looking their best. No matter what style of photography is being used, there are certain posing essentials that need to be at work. The more you know about the rules of posing and composition, and particularly the subtleties, the more you can apply to your wedding images. And the more you practice these principles, the more they will become second nature and a part of your technique.

Good posing technique is evident in this portrait by Parker J. Pfister. Notice her weight is on her back foot, creating a good line to the dress. Her near hand is on her hip, which creates a nice triangle base. The gaze over her near shoulder is a classic feminine pose, and the head-and-shoulder axis is at a decidedly different angle. Parker lit the scene with daylight coming from camera right from outside the arches (this is why he had her look toward the light). He vignetted the image top and bottom. Portraits like this show off the beauty of both the bride and her gown.

## Posing

**The Head-and-Shoulders Axis.** One of the basics of good posing is that the subject's shoulders should be turned at an angle to the camera. With the shoulders facing the camera, the person looks wider than he or she really is. Simultaneously, the head should be turned a different direction than the shoulders. This provides an opposing or complementary line within the photograph, that when seen together with the line of the body, creates a sense of tension and balance. With men, the head is often turned the same general direction as the shoulders (but not exactly the same angle); with women, the head is usually turned toward the near shoulder for the classic "feminine" pose.

Arms should not be allowed to fall to their sides, but should project outward to provide gently sloping lines and a "triangle base" to the composition. This is achieved by asking the subjects to move their arms away from their torsos. Remind them that there should be a slight space between their upper arms and their torsos. This triangular base in the composition directs the viewer's eye up toward the face.

**Weight on the Back Foot.** The basic rule of thumb is that no one should be standing at attention with both feet together. Instead, the shoulders should be at a slight angle to the camera and the front foot should be brought forward slightly. The subject's weight should generally be on the back leg/foot. This creates a bend in the front knee and causes the rear shoulder to drop slightly lower than the forward one. In full-length bridal portraits, a bent forward knee will give an elegant shape to the dress. With one statement, "Weight on your back foot," you have introduced a series of dynamic lines into an otherwise static pose.

**Head Angles.** The face should be viewed from at least slightly to the side. This is a much more attractive view than a straight-on pose. There are three basic head positions, relative to the camera, found in portraiture. Knowing the different head positions will help you provide

variety and flow to your images. In group images, you may end up using all three head positions in a single pose (the more people in the group, the more likely that becomes). Note that, with all of these head poses, the shoulders should still be at an angle to the camera.

*The Seven-Eighths View.* This is when the subject is looking slightly away from camera. If you consider the full face as a head-on "mug shot," then the seven-eighths view is when the subject's face is turned just slightly away from camera. In other words, you will see a little more of one side of the subject's face. You will still see the subject's far ear in a seven-eighths view.

*The Three-Quarters View.* The three-quarters view is achieved when the far ear is hidden from camera and more of one side of the face is visible. With this kind of pose, the far eye will appear smaller because it is farther away from the camera than the near eye. This makes it important, when posing subjects in a three-quarters view, to position them so that the smaller eye (people usually have one eye that is slightly smaller than the other) is closest to the camera. This way both eyes appear to be the same size.

Of course, you will not usually have the luxury of time to refine your group poses to this degree. When photographing the bride and groom, however, care should be taken to notice these subtleties.

*Profile.* In the profile the head is turned almost 90 degrees to the camera. Only one eye is visible. When pho-

*LEFT*—In this animated portrait, photographer Charles Maring had the bride look away towards some guests so that her face was in a three-quarters view, with her head tilted toward the near shoulder in a classic feminine pose. *RIGHT*—In this delightful three-quarter length portrait by Marcus Bell, the photographer positioned the bride's face so that it was in the seven-eighths view—almost straight on, but with slightly more of the right side of her face showing. She was positioned off to the side of the frame so the figure of the flower girl in the background would balance the composition.

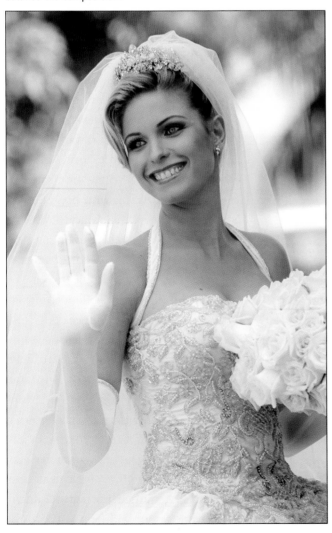 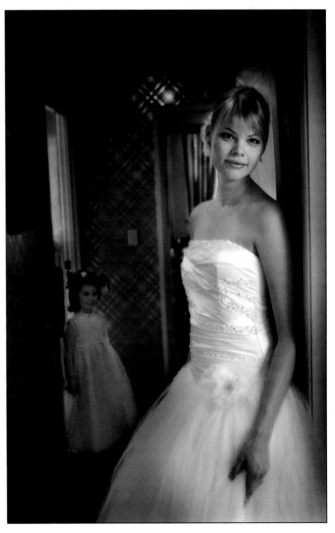

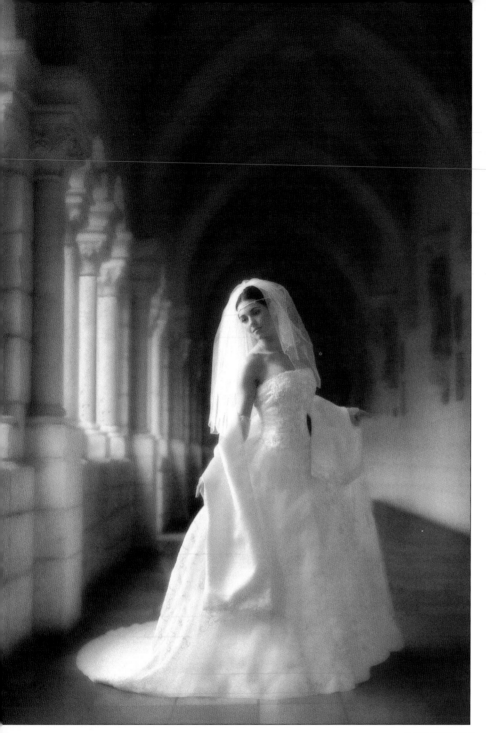

LEFT—In this elegant full-length portrait, Tom Muñoz captured just a bit of the hands, but they serve to extend the diagonal line in the portrait. Tom had her raise her arms slightly to show the wrap that is also part of the wedding gown. Notice the arch in her neck and back that creates a graceful curve to the composition. Tom had the bride tilt her head toward her near shoulder, and her gaze follows the forward arm to extend all the logical lines within the portrait. The lighting is all natural. The portico provided plentiful soft, side-daylight, and the natural stone acts as a neutral fill-in. FACING PAGE—Mauricio Donelli positioned his bride in the classic profile pose and then stretched the veil forward in the frame. The lighting was slightly behind her to create a shadow side facing the camera and highlight the frontal planes of her face and the gown. The careful lighting brings out the delicate beadwork in the wedding dress.

their eyes will smile—one of the most endearing expressions that people can make.

One of the best photographers I've ever seen at "enlivening" total strangers is Ken Sklute. In almost every one of his images, the people are happy and relaxed in a natural, typical way. Nothing ever looks posed in his photography—it's almost as if he happened by this beautiful picture and snapped the shutter. One of the ways he gets people "under his spell" is by his enthusiasm for the excitement of the day. It's contagious and his affability translates into attentive, happy subjects.

**Hands.** Hands can be strong indicators of character, just as the mouth and eyes are. Posing hands properly can be very difficult because in most portraits they are closer to the camera than the subject's head, and thus appear larger. One thing that will give hands a more natural perspective is to use a longer lens than normal (75–130mm in the 35mm digital format). Although holding the focus of both hands and face is more difficult with a longer lens, the size relationship between them will appear more natural. And if the hands are slightly out of focus, it is not as crucial as when the eyes or face of the portrait are soft.

One should never photograph a subject's hands pointing straight into the camera lens. This distorts the size

tographing profiles, adjust your camera position so that the far eyelashes disappear.

**The Gaze.** The direction the person is looking is important. If the subject is aware of your presence, start by having the person look at you. If you step away slightly and engage your subject in conversation, allowing you to hold the subject's gaze, you will create a slight rotation to the direction of the face. You can also have the person look away from you until you best utilize the light and flatter your subject. One of the best ways to enliven the subject's eyes is to tell an amusing story. If they enjoy it,

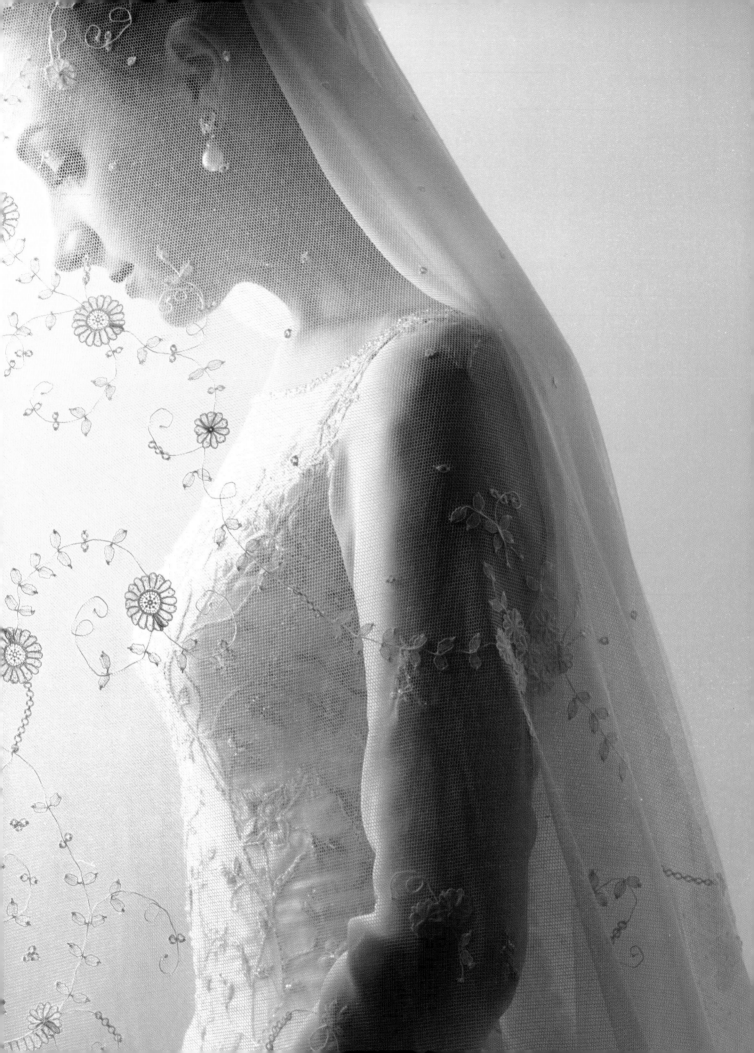

and shape of the hands. Always have the hands at an angle to the lens, and if possible, try to "bow" the wrist to produce a gentle sloping line. Try to photograph the outer edge of the hand when possible. This gives a natural, flowing line to the hand and wrist and eliminates distortion.

As generalizations go, it is important that women's hands have grace, and men's hands have strength.

## Camera Height

When photographing people with average features, there are a few general rules that govern camera height in relation to the subject. These rules will produce normal, undistorted perspective.

For head-and-shoulders portraits, the rule of thumb is that camera height should be the same height as the tip of the subject's nose. For three-quarter-length portraits, the camera should be at a height midway between the subject's waist and neck. In full-length portraits, the camera should be the same height as the subject's waist.

In each case, the camera is at a height that divides the subject into two equal halves in the viewfinder. This is so that the features above and below the lens–subject axis will be the same distance from the lens, and thus recede equally for "normal" perspective.

When the camera is raised or lowered, the perspective (the size relationship between parts of the photo) changes. When you raise your camera height, the portion of the subject below the lens axis becomes farther away, and thus appears smaller. Conversely, if you lower the camera height, the portion of the subject above the lens

axis becomes smaller because it is farther away from the film plane. This is particularly exaggerated with wide-angle lenses.

There are many reasons to raise or lower the camera height, most of which have to do with corrective portraiture—making a more flattering likeness by diminishing the effect of certain body parts. For instance with a middle-aged man who is overweight and balding, you might raise the camera angle and have him look up at the camera. While it won't cure his baldness, it will trim a few pounds from around his middle. Another example might be a bride with a wide forehead. In this case, lower the camera angle so that that area of her head is diminished in size because it is farther from the camera.

While there is little time for many such corrections on wedding day, knowing a few of these rules and introducing them into the way you photograph people will make many of these techniques second nature.

## Portrait Lengths

**Three-Quarter- and Full-Length Poses.** When you photograph a person in a three-quarter- or full-length pose, you have arms, legs, feet, and the total image of the body to deal with. A three-quarter-length portrait is one that shows the subject from the head down to a region below the waist.

Note that when you break the composition at a joint—an elbow, knee or ankle, for example—it produces a disquieting feeling. As a result, it is best to compose your three-quarter-length images with the bottom of the picture falling mid-thigh or mid-calf.

A full-length portrait shows the subject from head to toe. The person can be standing or sitting, but it is important to angle the person to the lens—usually at a 30- to 45-degree angle to the camera. If they are standing, make sure your subject has their weight on their back foot. Be sure to have the feet pointing at an angle to the camera. Feet look stumpy when shot head-on.

**Head-and-Shoulder Portraits.** With close-up portraits of one or more people, it is important to tilt the head and retain good head-and-shoulders-axis position-

FACING PAGE—Mauricio Donelli often takes studio flash equipment with him on weddings. Here, he used a feathered softbox to light the bride from the front. Using no fill made it look like a hall light was illuminating her. The volume and quality of light, however, are decidedly different. Mauricio used the mahogany doors to frame the shot and a pleasing profile pose to complete the unusual formal. The open door added depth and intimacy.

**LEFT**—Yervant photographed this intimate portrait of the bride and groom by employing a small shaft of elegant sunlight. He positioned his couple so that he could highlight the bride and groom's (to a lesser degree) lips. That is the focal point of the composition. He used his considerable Photoshop skills to darken selective areas of the portrait so that what you see is the bride's expression of emotional intoxication. But you will notice he left enough detail in the bodice of the dress to reveal its elegant design. There is much at work in this seemingly simple portrait. **FACING PAGE**—This is a classic semi-formal bridal portrait. Joe Buissink, knowing the weather report and studying the skies, kept telling the bride he wanted to make their formal portrait immediately because of the incoming storm. She kept putting him off until finally it began to pour, when she announced, "Okay, now I'm ready." Joe cautioned, "You'll get soaked!" She replied something like, "Let's do it," and the image you see here is the result. This image made the cover of numerous magazines and is a classic. Joe used a slower than normal shutter speed of $1/30$ second to record the falling rain—a photographic "I told you so!"

afraid to fill the frame with the bride or bride and groom's faces. They will never look as good as they do on their wedding day!

### Formal Portraits of the Couple

**Scheduling.** In your game plan, devote about 10 to 15 minutes to the formal portraits of the bride and groom alone. The bride can be done at her home before the wedding; the groom can be photographed at the ceremony before everyone arrives. You will have to wait, in most circumstances, until after the wedding ceremony (but before the reception) to photograph the bride and groom together. Often, formals are done before the bride and groom leave the church grounds.

**Formal Bridal Portrait.** In the bride's portrait, you must reveal the delicate detail and design elements of her bridal gown. Start with good head and shoulder axis, with one foot forward and weight on her back leg. Her head should be dipped toward the near (higher) shoulder, which places the entire body into a flattering "S-curve," a classic pose.

ing. Shoulders should be at an angle to the camera lens and the angle of the person's head should be at a slightly different angle. In these images, it is especially important to have a dynamic element, such as a diagonal line, which will create visual interest.

In a head-and-shoulders portrait, all of your camera technique will be evident, so focus is critical (start with the eyes) and lighting must be flawless. Then, use changes in camera height to correct any irregularities. Don't be

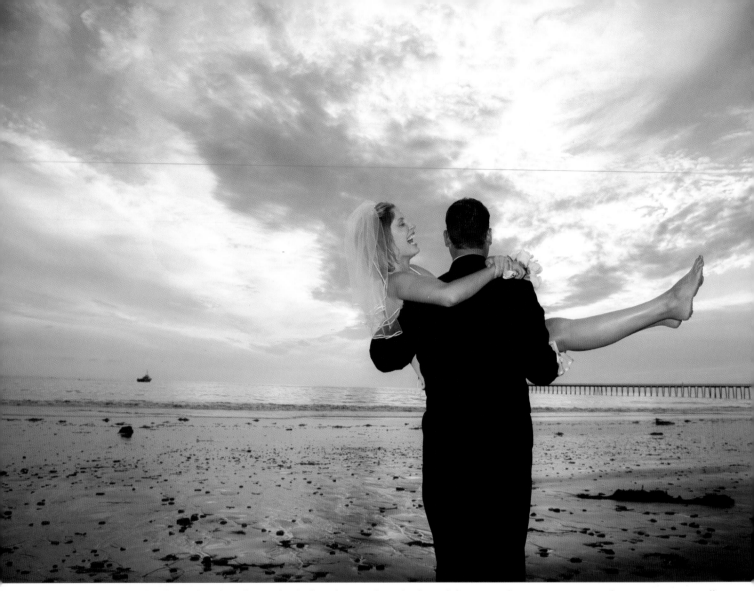

This is an example of a modern formal portrait—it doesn't even show the face of the groom, but concentrates on the gorgeous surroundings of the couples' wedding day. Michael Costa used flash fill in the waning light to keep the bride and groom at the same exposure settings as the twilight sky. The expression of the bride—a big old belly laugh—makes this image a huge hit.

The bouquet should be held in the same hand as the foot that is placed forward and the other hand should come in behind the bouquet. Have her hold the bouquet slightly below waist level, revealing the waistline of the dress while creating a flattering bend to the elbows.

For another portrait, turn her around and have her gaze back at you. This reveals the back of the dress, which is often quite elegant. Don't forget about the veil—shooting through the tulle material of the veil for a close-up portrait makes a fine portrait.

If the gown has a full train, you should devise a pose that shows it in its entirety, either draped around to the front or behind her. Remember, too, to have someone help her arrange and move the dress; you don't want the train dragging around in the flower beds.

If you photograph the bride outdoors by shade, or indoors in an alcove using the directional shade from outdoors, you will probably need an assistant to hold a reflector close to her to bounce additional light into her face. This will give a sparkle to her eyes and also fill in any shadows caused by directional lighting.

**Formal Portrait of the Groom.** Generally speaking, the groom's portrait should be less formal than the bride's. Strive for a relaxed pose that shows his strength and good looks. A three-quarter-length pose is ideal for the groom because you are less concerned about showing his entire ensemble than you are about the bride's.

If the groom is standing, use the same "weight on the back foot" philosophy as before. The front foot should be at an angle to the camera. With the shoulders angled

away from the camera lens, have the groom tilt his head toward the far shoulder in the classic "masculine" pose.

Side lighting often works well—and the classic arms-crossed pose is usually a winner; just remember to show the edge of the hands and not let him "grab" his biceps, as this will make him look like he's cold.

Another good pose is to have the groom's hands in his pockets in a three-quarter-length pose. Have his thumbs hitched on his pants pockets so that you can break up all of the dark tones of his tuxedo. Also, if he has cuffs and cuff links, adjust his jacket sleeves so that the cuffs and cuff links show and look good. It's always a good idea to check the groom's necktie to make sure it's properly tied.

Another good pose is to have him rest one foot on a stool, bench, or other support that is out of view of the camera. He can then lean forward toward the camera on his raised knee.

A gentle smile is better than a serious pose—or one of the "big smiley laughing" variety. Although there are no hard and fast rules here, "strong" and "pleasant" are good attributes to convey in the groom's portrait.

The men's fashion magazines are a good source of information on contemporary poses.

**Formal Portrait of the Bride and Groom.** The most important formal portrait is the first picture of the bride and groom immediately after the ceremony. Take at least two portraits, a full-length shot and a three-quarter-length portrait. These can be made on the grounds of the church or synagogue, in a doorway, or in some other pleasant location, directly following the ceremony.

The bride should be positioned slightly in front of the groom and they should be facing each other but each at a 45 degree angle to the camera. Weight should be on the back leg for both, and there should be a slight bend in the knee of the bride's front leg, giving a nice line to

This is a wonderful bridal portrait by Yervant, who used the strong backlighting to silhouette his couple. Notice the details that highlight the great emotion between them and the cacophony of fingers intertwined. Instead of distracting from the composition, these serve to enhance the great connection between them. This is the stuff modern brides love.

This is a very traditional pose by Ken Sklute, who is a master at posing small and large groups. The symmetry of the bridal outfits helped him realize a very symmetrical posing would be the best in the midst of the Spanish architecture, which is also very formal and symmetrical. Even the center-most subjects are posed at an angle, so that everything faces the center of the group. With this many people, it's a good idea to shoot multiple frames in case there's a blink or two.

the dress. They will naturally lean into each other. The groom should place his hand in the center of the bride's back and she should have her bouquet in her outside hand (the other hand can be placed behind it).

Have your assistant ready and waiting in the predetermined location and take no more than five minutes making this portrait. Your assistant should have ready the reflectors, flash, meter, or other gear you will need to make the portrait.

Vary your poses so that you get a few with them looking at each other and a few looking into the camera. This is a great time to get a shot of them kissing. Believe it or

not, very few images like this get made on the wedding day, because the couple is so busy attending to details and guests.

## Group Portraits

You will need to photograph the groom and his groomsmen, the bride and her bridesmaids, as well as the complete wedding party in one group. Other groups you will need to photograph depend on the wishes of the couple. They may want family formals (his and hers), extended families (this is a much bigger group, usually), or a giant group shot including all of the attendees.

You do not have to make the portraits boy–girl, boy–girl. That is usually a pretty boring shot, even if you have

Two arm chairs create the posing stage for this large group. Everyone's pose appears natural and beautiful and the expressions are controlled—in part, by host/photographer Ken Sklute, who keeps things entertaining for all.

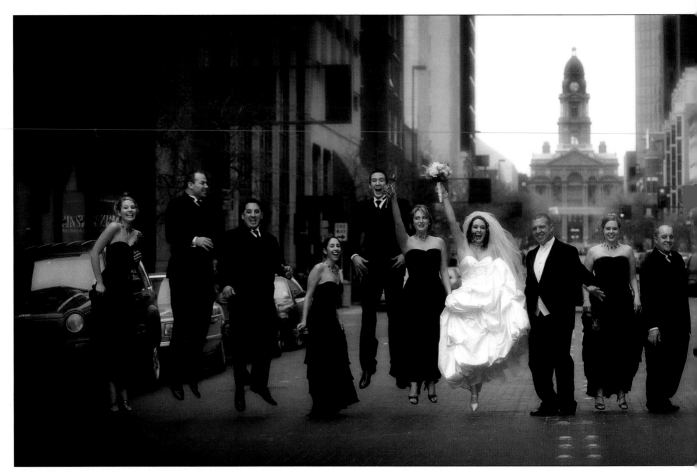

JB Sallee shoots a lot of panoramic groups but doesn't use a panoramic camera. This image was made with a Kodak Pro DCS 14N with a 70mm lens. Apparently, half the group got the message to jump and the other half didn't, but still this is an enjoyable group portrait. The title of the photo is *Jump, Damn It!*

a great background and all else is perfect. Instead, opt for something completely unexpected. Incorporate the environment or architecture or ask your wedding group to do something uncharacteristic. Even though this is a formal, posed shot, it does not have to represent a pause in the flow of the wedding day—it can still be fun and you can still get a wonderful group image if you exercise a little ingenuity.

**Variety.** While it might be tempting to find a great background and shoot all of your groups with the same background, the effect will be monotonous when seen in the album. Strive for several interesting backgrounds, even if they are only a short distance apart. It will add visual interest to the finished album.

**Compositional Elements.** Designing groups successfully depends on your ability to manage the implied and inferred lines and shapes within a composition.

Lines are artistic elements used to create visual motion within the image. They may be implied by the

arrangement of elements in the group, or inferred by grouping various elements within the scene. Lines can also be literal, like a fallen tree used as a posing bench that runs diagonally through the composition.

Shapes are groupings of like elements into diamonds, circles, pyramids, etc. These shapes are usually a collection of faces that form a pattern. They are used to produce pleasing forms that guide the eye through the composition.

The more you learn to recognize these elements, the more they will become an integral part of your compositions. These are the keys to making a dynamic group portrait. The goal is to move the viewer's eye playfully and rhythmically through the photograph.

**Number of Subjects.** *Two People.* The simplest of groups is two people. Whether the group is a bride and groom, mom and dad, or the best man and the maid of honor, the basic building blocks call for one person slightly higher than the other. A good starting point is to

position the mouth of the shorter person in line with the forehead or eyes of the taller person.

Although they can be posed in parallel position, a more interesting dynamic with two people can be achieved by having them pose at 45-degree angles to each other so their shoulders face in toward one another. With this pose you can create a number of variations by moving them closer or farther apart.

Another pose for two is to have two profiles facing each other. One should still be higher than the other, allowing you to create an implied diagonal line between the eyes, which gives the portrait better visual dynamics.

Since this type of image is fairly close up, make sure that the frontal planes of the subject's faces are kept roughly parallel so that you can hold the focus on both faces.

*Three People.* A group portrait of three is still small and intimate. But once you add a third person, you will begin to notice the interplay of line and shape inherent in good group design. This size group lends itself particularly well to a pyramid, diamond, or inverted-triangle composition, all of which are pleasing to the eye. Note that the graphic

power of a well defined diagonal line in a composition will compel the viewer to keep looking at the image.

To loop the group together, turn the shoulders of the subjects at either ends of the group in toward the center of the frame. A more subtle approach might be to just tilt the heads of those people on the end in toward the center of the group.

Also, try different vantage points, like a bird's-eye view. Cluster the group together, use a safe stepladder or other high vantage point, and you've got an interesting variation on the small group.

*Four People.* With four people, add a person to the existing poses of three described above. Be sure to keep the head height of the fourth person different from any of the others in the group. Also, be aware that you are now forming more complex shapes with your composition—pyramids, extended triangles, diamonds and arcs.

You will find that even numbers of people are harder to pose than odd. Three, five, seven, or nine people seem much easier to photograph than their even-numbered counterparts. The reason is that the eye and brain tend to accept the disorder of odd-numbered objects (asymmetry) more readily than even-numbered objects (symmetry). As you add more people to a group, remember to do everything you can to keep the film plane parallel to the plane of the group to ensure everyone in the photograph is sharply focused.

*Five or Six People.* With five or six people, you should begin to think in terms of separate groups tied to each other by a person who is common to both.

This is when a posing device like an armchair can come into play. An armchair is the perfect posing device for photographing from three to eight people. The chair is best positioned roughly 30 to 45 degrees to the camera. Regardless of who will occupy the seat, usually the bride, they should be seated laterally across the cushion and posed on the edge of the chair so that all of their weight does not rest on the chair back. This promotes good sitting posture and narrows the lines of the waist and hips, for both men and women.

Using an armchair allows you to seat one person and position the others close and on the arms of the chair, leaning in toward the central person. Sometimes only one arm of the armchair is used to create a more dynamic triangle shape.

*Big Groups.* In big groups, the use of different levels creates a sense of visual interest and lets the viewer's eye bounce from one face to another (as long as there is a logical and pleasing flow to the arrangement). The placement of faces, not bodies, dictates how pleasing and effective a composition will be.

As your groups get bigger, keep your depth of field under control. The stepladder is an invaluable tool for larger groups because it lets you elevate the camera position so that you can keep the camera back (film plane) parallel to the group for most efficient focus. Another trick is to have the last row in a group lean in while having the first row lean back. This creates a shallower subject plane, which makes it easier to hold the focus across the entire group.

Two things you should remember about photographing large groups are (1) an assistant is invaluable in getting all of the people together and helping you to pose them, and (2) it takes less time to photograph one large group than it does to create a series of smaller groups, so it is usually time well spent— provided that the bride wants the groups done in this way.

**Panoramic Groups.** If you have the capability of producing panoramic pages in your album, this is a great way to feature groups, especially large ones. Your camera technique will definitely show up with images this large, so be sure the plane of focus is aligned with your group and that everyone is in focus. Also, as needed, use the proper amount of fill-flash to fill in facial shadows across the group.

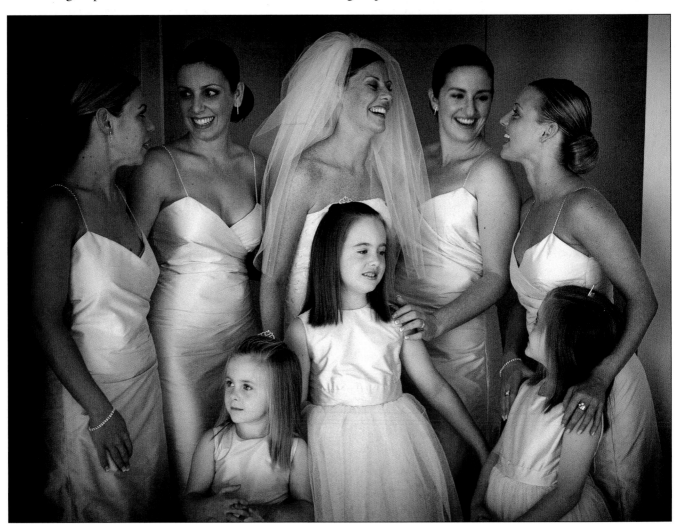

Marcus Bell is a maestro at capturing the essential moment of a scene, especially with small groups of people. Here, his lighting was less than optimum, but it appears relatively even throughout thanks to reflected daylight from a large hotel-room bay window. Even with an increased ISO of 800, the dim light meant he still picked up a little subject movement—but the great expressions more than make up for this. Marcus always carries several portable flash units, but resists using them when doing so might break the mood of the moment.

When I began writing this book, I wanted it to represent the highest levels of lighting excellence. The photographers whose work appears here represent that level of excellence. I want to thank all of them for their participation in this book.

**Fernando Basurto** *(APM, AOPA).* Fernando is an accomplished wedding photographer who does business in historical uptown Whittier area of Southern California. Specializing in wedding photojournalism Fernando has created some of the most powerful and passionate wedding images of today. His work can be seen at www.elegantphotographer.com/.

**Becker.** Becker, who goes by only his last name, is a gregarious, likeable wedding photojournalist who operates a hugely successful studio in Mission Viejo, CA. He has been a featured speaker at WPPI and has also competed and done well in international print competition.

**David Beckstead.** David Beckstead has lived in a small town in Arizona for over twenty years. With help from the Internet, forums, seminars, WPPI, Pictage, and his artistic background, his passion has grown into an international wedding photography business. He refers to his style of wedding photography as "artistic photojournalism."

**Marcus Bell.** Marcus's creative vision, natural style, and sensitivity have made him one of Australia's most revered photographers. His work has been published in *Black White, Capture, Portfolio Bride,* and countless bridal magazines.

**Don Blair.** For fifty years, the name Don Blair was synonymous with fine portraiture, craftsmanship and extraordinary contributions to the industry. It's no accident that he is among the most respected of all portrait photographers. Don was affectionately known to many as "Big Daddy."

**Joe Buissink.** Joe Buissink is an internationally recognized wedding photographer from Beverly Hills, CA. Almost every potential bride who picks up a bridal magazine will have seen Joe Buissink's photography. He has done numerous celebrity weddings, including Christina Aguilera's 2005 wedding, and is a multiple Grand Award winner in WPPI print competition.

**Drake Busath** *(Master Photographer, Craftsman).* Drake Busath is a second-generation professional photographer who has spoken all over the world and has been featured in a wide variety of professional magazines. Drake also runs a popular photography workshop series in Northern Italy.

**Mark Cafeiro.** Mark holds a degree in business administration with special emphasis in marketing, and is the owner of three photography businesses, including Pro Photo Alliance, a turnkey online proofing solution for photo labs and other professional photographers, a college event photography company, and his own private wedding, event, and portrait business.

**Mike Colón.** Mike's images have appeared in *Grace Ormonde Wedding Style, Modern Bride,* and *The Knot*— and Nikon recently named him a "legend behind the lens." Mike has traveled the world photographing weddings for the rich and famous. He also travels regularly to teach and share his passion for photography with others. Mike resides in Newport Beach, CA.

**Michael Costa.** Michael Costa is an award-winning photographer who graduated with honors from the world-renowned Brooks Institute of Photography in Santa Barbara, CA, receiving the coveted Departmental

Award in the Still Photography program. He started his successful business with his wife, Anna during his last year at Brooks.

**Cherie Steinberg Coté.** Cherie began her career as a photojournalist and was the female freelance photographer at the *Toronto Sun*. Cherie currently lives in Los Angeles and has recently been published in the *L.A. Times, Los Angeles Magazine,* and *Towne & Country.*

**Dan Doke.** Daniel has a drive for perfection, abundant creativity, and special eye for light and form. He is a modern photographer with traditional skills, who draws on his experience in commercial, fashion, and portrait photography to create memorable wedding images.

**Mauricio Donelli.** Mauricio Donelli is a world-famous wedding photographer from Miami, FL. His photographs have been published in *Vogue, Town & Country,* and many national and international magazines. Mauricio has photographed weddings around the world.

**Bruce Dorn.** Twenty years of Hollywood filmmaking experience have shaped Bruce's cinematic style of photography. With his artistic partner and wife Maura Dutra, he owns iDC Photography, which specialized in wedding-day coverage for artistically-inclined clients.

**William L. Duncan** (*M.Photog. CPP, APM, AOPM, AEPA*). Bill Duncan was one of the original members of WPPI with three levels of achievement. He has been a consistent winner in print competitions from all organizations, and he is known around country for his unique images. He is an instructor of "Artistry in The Language of Light" seminars.

**Rick Ferro.** Rick has served as senior wedding photographer at Walt Disney World and received many awards from WPPI. He is the author of *Wedding Photography: Creative Techniques for Lighting and Posing,* and coauthor of *Wedding Photography with Adobe Photoshop,* both from Amherst Media.

**Brett Florens.** Having started his career as a photojournalist, Brett Florens has become a renowned international wedding photographer, traveling from his home in South Africa to Europe, Australia and the U.S. for the discerning bridal couple requiring the ultimate in professionalism and creativity. His exceptional albums are fast making him the "must have" photographer around the globe.

**Jerry Ghionis.** Jerry Ghionis of XSiGHT Photography and Video is one of Australia's leading photographers, and his versatility extends to the wedding, portrait, fashion, and corporate fields. In 2003, he won Wedding Album of the Year and the Grand Award in the Album competition at WPPI.

**Greg Gibson.** Greg is a two-time Pulitzer Prize winner whose assignments have included three Presidential campaigns, daily coverage of the White House, the Gulf War, Super Bowls, and much more. Despite numerous offers to return to journalism, Greg finds shooting weddings the perfect genre to continually test his skills.

**Al Gordon.** Al operates a full-service studio and has photographed weddings throughout the Southeast. In addition to holding numerous degrees from PPA and WPPI, he received the coveted Kodak Trylon Gallery Award twice and has images in the coveted ASP Masters Loan Collection.

**Jo Gram and Johannes Van Kan**. Johannes and Jo are the principals at New Zealand's Flax Studios, which caters to high-end wedding clients. Johannes has a background in newspaper photography; Jo learned her skills assisting top wedding photographers. In 2005, they teamed up—and they have been winning major awards in both Australia and New Zealand ever since.

**Jeff and Kathleen Hawkins.** Jeff and Kathleen operate a high-end wedding and portrait photography studio in Orlando, FL, and are the authors of *Professional Marketing & Selling Techniques for Wedding Photographers* (Amherst Media). Jeff has been a professional photographer for over twenty years. Kathleen holds an MBA and is a past president of the Wedding Professionals of Central Florida (WPCF). They can be reached at www.jeffhawkins.com.

**Kevin Jairaj.** Kevin is a fashion photographer turned wedding and portrait photographer whose creative eye has earned him a stellar reputation in the Dallas/Fort Worth, TX area. His web site is: www.kjimages.com.

**Jeff Kolodny.** Jeff began his career as a professional photographer in 1985 after receiving a BA in Film Production from Adelphi University in New York. Jeff recently relocated his business from Los Angeles to South Florida, where his goal is to produce cutting-edge digital wedding photography.

**Scott Robert Lim.** Scott is an Los Angeles photographer and educator with a compelling style that blends both photojournalism and portraiture with a modern

flare. He is a preferred photographer at many world-renowned establishments, such as the Hotel Bel-Air.

**Charles and Jennifer Maring.** Charles and Jennifer own and operate Maring Photography Inc. in Wallingford, CT, which is also home to Rlab (www.resolutionlab.com), a digital lab for discriminating photographers needing high-end digital work.

**Cliff Mautner.** Cliff Mautner began his career as a photojournalist and never dreamed that he would be enjoying wedding photography as much as he does. His images have been featured in *Modern Bride, Elegant Wedding, The Knot,* and other wedding publications.

**Tom Muñoz.** Tom Muñoz is a fourth-generation photographer whose studio is located in Fort Lauderdale, FL. Tom upholds the classic family traditions of posing, lighting, and composition, yet is 100% digital in the studio operation. He believes that the traditional techniques blend perfectly with exceptional quality of digital imaging.

**Mark Nixon.** Mark, who runs The Portrait Studio in Clontarf, Ireland, recently won Ireland's most prestigious photographic award with a panel of four wedding images. He is currently expanding his business to be international in nature and he is on the worldwide lecture circuit.

**Dennis Orchard.** Dennis Orchard is an award-winning photographer from Great Britain. He has been a speaker and an award winner at WPPI conventions and print competitions. His unique lifestyle wedding photography has earned many awards, including UK Wedding Photographer of the Year, International Wedding Photojournalism Print of the Year, and WPPI's highest honor, the Accolade of Lifetime Photographic Excellence.

**Parker Pfister.** Parker Pfister, who shoots weddings locally in Hillsboro, OH, as well as in neighboring states, is quickly developing a national celebrity. He is passionate about what he does and can't imagine doing anything else (although he also has a beautiful portfolio of fine-art nature images). Visit him at www.pfisterphoto-art.com

**Joe Photo.** Joe Photo is the rock star of the wedding photography world. His stunning wedding images have been featured in numerous books and magazines, as well as on NBC's *Life Moments,* the Lifetime channel's *Weddings of a Lifetime,* and Lifetime's reality show *My Best Friend's Wedding.*

**JB and DeEtte Sallee.** Sallee Photography has only been in business since 2003, but it has already earned many accomplishments. In 2004, JB received the first Hy Sheanin Memorial Scholarship through WPPI. In 2005, JB and DeEtte were also named Dallas Photographer of The Year.

**Kenneth Sklute.** Beginning his wedding photography career at sixteen in Long Island, NY, Kenneth quickly advanced to shooting an average of 150 weddings a year. About ten years ago, he moved to Arizona, where he enjoys a thriving business. Kenneth is much decorated, having been named Long Island Wedding Photographer of the year fourteen times and PPA Photographer of the Year. In addition, he has earned numerous Fuji Masterpiece Awards and Kodak Gallery Awards.

**Alisha and Brook Todd.** Alisha and Brook's studio in Aptos, CA (near San Francisco) is fast becoming known for its elite brand of wedding photojournalism. Both Alisha and Brook photograph the wedding with "one passion and two visions." The Todds are members of both PPA and WPPI and have been honored in WPPI's annual print competition.

**Marc Weisberg.** Marc Weisberg's interest in the culinary arts has led him to create numerous images for marketing and public relations campaigns, as well as images featured in *Wines and Spirits, Riviera, Orange Coast,* and *Where Los Angeles.*

**Jeffrey and Julia Woods.** Jeffrey and Julia are award-winning wedding and portrait photographers who work as a team. They have won two Fuji Masterpiece awards and a Kodak Gallery Award. See more of their images at www.jwweddinglife.com.

**Yervant Zanazanian** (*M. Photog. AIPP, F.AIPP*). Yervant was born in Ethiopia, then lived and studied in Venice prior to settling in Australia. He now owns one of the country's most prestigious photography studios and has been Australia's Wedding Photographer of the Year three of the past four years.

# GLOSSARY

**Absorption.** One of the characteristics of light. Absorption occurs when no light is transmitted or reflected from a surface. Absorption usually results in heat, but not light.

**Angle of incidence.** The original axis on which light travels. The angle of reflection is the secondary angle light takes when reflected off of some surface. The angle of incidence is equal to the angle of reflection.

**Barebulb flash.** A portable flash unit with a vertical flash tube that fires the flash illumination 360 degrees.

**Barn doors.** Black, metal folding doors that attach to a light's reflector. These are used to control the width of the beam of light.

**Black flag.** Light-blocking card that is supported on a stand or boom and positioned between the light source and subject to selectively block light from portions of the scene. Also known as a gobo.

**Boom arm.** A light stand accessory that uses a heavy counterweight on one end of a pole to balance the weight of a softbox or other light modifier.

**Box light.** A diffused light source housed in a box-shaped reflector. The bottom of the box is translucent material; the side pieces of the box are opaque, but they are coated with a reflective material such as foil on the inside to optimize output.

**Bounce flash.** Bouncing the light of a studio or portable flash off a surface such as a ceiling or wall to produce indirect, shadowless lighting.

**Broad lighting.** One of two basic types of portrait lighting in which the key light illuminates the side of the subject's face turned toward the camera.

**Burning-in.** A darkroom technique in which specific areas of the print surface are given additional exposure in order to darken them. Emulated in Photoshop.

**Burst rate.** The number of frames per second (fps) a digital camera can record images and the number of frames per exposure sequence it can record. Typical burst rates range from 2.5fps up to six shots, all the way up to 8fps up to forty shots.

**Butterfly lighting.** One of the basic portrait lighting patterns, characterized by a high key light placed directly in line with the line of the subject's nose. This lighting produces a butterfly-like shadow under the nose. Also called paramount lighting.

**Catchlight.** The specular highlights that appear in the iris or pupil of the subject's eyes, reflected from the portrait lights.

**CC filters.** Color-compensating filters that come in gel or glass form and are used to correct the color balance of a scene.

**CF card reader.** A device used to connect a CF card or microdrive to a computer. CF card readers are used to download image files from a capture and/or storage device to your computer workstation.

**CMOS (Complementary Metal Oxide Semiconductor).** A type of semiconductor that has been, until the Canon EOS D30, widely unavailable for digital cameras. CMOS chips are less energy consuming than other chips that utilize simply one type of transistor.

**Color temperature.** The degrees Kelvin of a given light source. Also refers to a film's sensitivity. Color films are balanced for either 5500K (daylight), 3200K (tungsten), or 3400K (photoflood).

**Cove.** A seamless backdrop or lighting table with no horizon line. The angle where horizontal and vertical planes intersect is curved.

**Cross lighting.** Lighting that comes from the side of the subject, skimming facial surfaces to reveal the maximum texture in the skin. Also called sidelighting.

**Cross shadows.** Shadows created by lighting a group with two light sources from either side of the camera. These should be eliminated to restore the "one-light" look.

**Depth of field.** The distance that is sharp beyond and in front of the focus point at a given f-stop.

**Diffusion flat.** Portable, translucent diffuser that can be positioned in a window frame or near the subject to diffuse the light striking the subject. Also known as a scrim.

**Dodging.** Darkroom printing technique or Photoshop technique in which specific areas of the print are given less print exposure by blocking the light to those areas of the print, making those areas lighter.

**Dots.** Small circular black cards attached to stiff wire stems held in place with a C-stand or other support to block light from reaching certain areas of the scene. These miniature gobos are sometimes used in small product lighting setups. Also known as fingers.

**Dragging the shutter.** Using a shutter speed slower than the X sync speed in order to capture the ambient light in a scene.

**Fashion lighting.** Type of lighting that is characterized by its shadowless light and its proximity to the lens axis. Fashion lighting is usually head-on and very soft in quality.

**Feathered edge.** Also known as the penumbra; the soft edge of the circular light from a light in a parabolic reflector.

**Feathering.** Misdirecting the light deliberately so that the edge of the beam of light illuminates the subject.

**Fill card.** A white or silver-foil-covered card used to reflect light back into the shadow areas of the subject.

**Fill light.** Secondary light source used to fill in the shadows created by the key light.

**Fingers.** *See* Dots.

**Flash-fill.** Flash technique that uses electronic flash to fill in the shadows created by the main light source.

**Flashing.** A darkroom technique used in printing to darken an area of the print by exposing it to raw light. The same technique can be achieved in Photoshop using a transparent vignette.

**Flash-key.** Flash technique in which the flash becomes the main light source and the ambient light in the scene fills the shadows created by the flash.

**Flashmeter.** A handheld incident light meter that measures both the ambient light of a scene and when connected to an electronic flash, will read flash only or a combination of flash and ambient light. They are invaluable for determining outdoors flash exposures and lighting ratios.

**Flat.** A large white or gray reflector usually on casters that can be moved around a set for bouncing light onto the set or subject.

**Focusing an umbrella.** Adjusting the length of the exposed shaft of an umbrella in a light housing to optimize light output.

**45-degree lighting.** Portrait lighting pattern characterized by a triangular highlight on the shadow side of the face. Also known as Rembrandt lighting.

**Fresnel lens.** The glass filter on a spotlight that concentrates the light rays in a spotlight into a narrow beam of light.

**Full-length portrait.** A pose that includes the full figure of the model. Full-length portraits can show the subject standing, seated or reclining.

**Gaussian blur.** Photoshop filter that diffuses a digital image.

**Gobo.** Light-blocking card that is supported on a stand or boom and positioned between the light source and subject to selectively block light from portions of the scene.

**Grayscale.** Color model consisting of up to 254 shades of gray plus absolute black and absolute white. Every pixel of a grayscale image displays as a brightness value ranging from 0 (black) to 255 (white). The exact range of grays represented in a grayscale image can vary.

**Groundglass.** The camera's focusing screen on which the image is focused.

**Head-and-shoulder axis.** Imaginary lines running through shoulders (shoulder axis) and down the ridge of the nose (head axis). Head-and-shoulder axes should never be perpendicular to the line of the lens axis.

**High-key lighting.** Type of lighting characterized by low lighting ratio and a predominance of light tones.

**Highlight brilliance.** Refers to the specularity of highlights on the skin. A negative with good highlight brilliance shows specular highlights (paper base white) within a major highlight area. Achieved through good lighting and exposure techniques.

**Histogram.** A graph associated with a single image file that indicates the number of pixels that exist for each brightness level. The range of the histogram represents 0 to 255 from left to right, with 0 indicating "absolute" black and 255 indicating "absolute" white.

**Hot spots.** A highlight area of the negative that is overexposed and without detail. Sometimes these areas are etched down to a printable density.

**Incident light meter.** A handheld light meter that measures the amount of light falling on its light-sensitive dome.

**Inverse Square Law.** A behavior of light that defines the relationship between light and intensity at varying distances. The Inverse Square Law states that the illumination is inversely proportional to the square of the distance from the point source of light.

**JPEG (Joint Photographic Experts Group).** JPEG is an image file format with various compression levels. The higher the compression rate, the lower the image quality, when the file is expanded (restored). Although there is a form of JPEG that employs lossless compression, the most commonly used forms of JPEG employ lossy compression algorithms, which discard varying amounts of the original image data in order to reduce file storage size.

**Key light.** The main light in portraiture used to establish the lighting pattern and define the subject's facial features.

**Kicker.** A backlight (a light coming from behind the subject) that highlights the hair or contour of the body.

**Levels.** In Photoshop, Levels allows you to correct the tonal range and color balance of an image. In the Levels window, Input refers to the original intensity values of the pixels in an image and Output refers to the revised color values based on your adjustments.

**Lighting ratio.** The difference in intensity between the highlight side of the face and the shadow side of the face. A 3:1 ratio implies that the highlight side is three times brighter than the shadow side of the face.

**Loop lighting.** A portrait lighting pattern characterized by a loop-like shadow on the shadow side of the subject's face. Differs from paramount or butterfly lighting because the main light is slightly lower and farther to the side of the subject.

**Low-key lighting.** Type of lighting characterized by a high lighting ratio and strong scene contrast as well as a predominance of dark tones.

**Main light.** Synonymous with key light.

**Modeling light.** A secondary light mounted in the center of a studio flash head that gives a close approximation of the lighting that the flash tube will produce. Usually high intensity, low-heat output quartz bulbs.

**Monolight.** A studio-type flash that is self-contained, with its own capacitor and discharge circuitry. Monolights come with internal Infrared triggers so the light can be fired without directly connecting the flash to a camera or power pack.

**Over-lighting.** Main light is either too close to the subject, or too intense and over-saturates the skin with light, making it impossible to record detail in highlighted areas. Best corrected by feathering the light or moving it back.

**Parabolic reflector.** Oval-shaped dish that houses a light and directs its beam outward in an even controlled manner.

**Paramount lighting.** One of the basic portrait lighting patterns, characterized by a high key light placed directly in line with the line of the subject's nose. This lighting produces a butterfly-like shadow under the nose. Also called butterfly lighting.

**Penumbra.** The soft edge of the circular light pattern from a light in a parabolic reflector. It is also known as the feathered edge of the undiffused light source.

**Pixel (picture element).** Smallest element used to form an image on a screen or paper. Thousands of pixels are used to display an image on a computer screen or print an image from a printer.

**Point light source.** A sharp-edged light source like the sun, which produces sharp-edged shadows without diffusion.

**RAW.** A file format, which uses lossless compression algorithms to record picture data as is from the sensor, without applying any in-camera corrections. In order to use images recorded in the RAW format, files must first be processed by compatible software. RAW processing includes the option to adjust exposure, white balance and the color of the image, all the while leaving the original RAW picture data unchanged.

**Reciprocity Failure.** A characteristic of film. Reciprocity failure is a decrease in light sensitivity with increased or decreased length of exposure. Typically, all exposure settings are reciprocal between $\frac{1}{2}$ second and $\frac{1}{8,000}$ second. Outside of that range the film loses sensitivity and additional exposure and color correction must be applied, depending on individual emulsion characteristics.

**Reflected light meter.** A meter that measures the amount of light reflected from a surface or scene. All in-camera meters are of the reflected type.

**Reflection.** One of the behaviors of light. Light striking an opaque or semi-opaque surface will either reflect light at various angles, transmit light through the surface or be absorbed by the surface.

**Reflector.** 1) Same as fill card. 2) A housing on a light that reflects the light outward in a controlled beam.

**Refraction.** When light is transmitted through a surface, it changes speed and is misdirected at an angle different from its incident angle. Different surfaces bend or refract light in known quantities. The definition of a given material's refractive characteristics is known as its refractive index.

**Rembrandt lighting.** Same as 45-degree lighting.

**Rim lighting.** Portrait lighting pattern where the key light is behind the subject and illuminates the edge of the subject. Most often used with profile poses.

**Seven-eighths view.** Facial pose that shows approximately $\frac{7}{8}$ of the face. Almost a full-face view as seen from the camera.

**Scatter.** A characteristic of light. When light is transmitted through a translucent medium in changes directions and is transmitted at a wide variety of different angles. The transmitted light is known as scatter.

**Scrim.** A panel used to diffuse sunlight. Scrims can be mounted in panels and set in windows, used on stands, or they can be suspended in front of a light source to diffuse the light.

**Shadow.** An area of the scene on which no direct light is falling making it darker than areas receiving direct light (*i.e.* highlights).

**Shadow edge.** Where a highlight and shadow meet on a surface is the shadow edge. With hard light, the shadow edge is abrupt. With soft light the shadow edge is gradual. Also known as the transfer edge.

**Sharpening.** In Photoshop, filters that increase apparent sharpness by increasing the contrast of adjacent pixels within an image.

**Short lighting.** One of two basic types of portrait lighting in which the key light illuminates the side of the face turned away from the camera.

**Slave.** A remote triggering device used to fire auxiliary flash units. These may be optical, or radio-controlled.

**Snoot.** A conical accessory that attaches to a light housing's reflector and narrows the beam of light. Snoots allow the illumination of very small areas with relatively bright light.

**Softbox.** Same as a box light. Can contain one or more light heads and single or double-diffused scrims.

**Specular highlights.** Sharp, dense image points on the negative. Specular highlights are very small and usually appear on pores in the skin. Specular highlights are pure white with no detail.

**Split lighting.** Type of portrait lighting that splits the face into two distinct areas: shadow side and highlight side. The key light is placed far to the side of the subject and slightly higher than the subject's head height.

**Spotmeter.** A handheld reflected light meter that measures a narrow angle of view—usually from 1 to 4 degrees.

**Spots.** Spotlights; a small sharp light that uses a Fresnel lens to focus the light from the housing into a narrow beam.

**sRGB.** Color matching standard jointly developed by Microsoft and Hewlett-Packard. Cameras, monitors, applications, and printers that comply with this standard are able to reproduce colors the same way. Also known as a color space designated for digital cameras.

**Straight flash.** The light of an on-camera flash unit that is used without diffusion (*i.e.*, straight).

**Subtractive fill-in.** Lighting technique that uses a black card to subtract light out of a subject area in order to create a better defined lighting ratio. Also refers to the placement of a black card over the subject in outdoor portraiture to make the light more frontal and less overhead in nature.

**Sweep table.** A translucent table for lighting small products and still lifes. It is characterized by a curved horizon line so that objects can be photographed with a seamless background.

**TTL-balanced fill-flash.** Flash exposure systems that read the flash exposure through the camera lens and adjust flash output to compensate for flash and ambient light exposures, producing a balanced exposure.

**Three-quarter-length pose.** Pose that includes all but the lower portion of the subject's anatomy. Can be from above knees and up, or below knees and up.

**Three-quarters view.** Facial pose that allows the camera to see ¾ of the facial area. Subject's face is usually turned 45 degrees away from the lens so that the far ear disappears from camera view.

**TIFF (Tagged Image File Format).** File format commonly used for image files. There are several kinds of TIFF files. TIFF files are lossless, meaning that no matter how many times they are opened and closed, the data remains the same, unlike JPEG files, which are designated as lossy files, meaning that data is lost each time the files are opened and closed.

**Transfer edge.** *See* Shadow edge.

**Umbrella lighting.** Type of soft, casual lighting that uses one or more photographic umbrellas to diffuse the light source(s).

**Umbra.** The hot center portion of the light pattern from an undiffused light in a parabolic reflector.

**Unsharp mask.** A sharpening tool in Adobe Photoshop that is usually the last step in preparing an image for printing.

**Vignette.** A soft-edged border around the main subject. Vignettes can be either light or dark in tone and can be included at the time of shooting, or added later in printing.

**Watt-seconds (Ws).** Numerical system used to rate the power output of electronic flash units. Primarily used to rate studio strobe systems.

**White balance.** The camera's ability to correct color and tint when shooting under different lighting conditions including daylight, indoor and fluorescent lighting.

**Wraparound lighting.** Soft type of light, produced by umbrellas, that wraps around the subject, producing a low lighting ratio and open, well-illuminated highlight areas.

**X sync.** The shutter speed at which focal-plane shutters synchronize with electronic flash.

**Zebra.** A term used to describe reflectors or umbrellas having alternating reflecting materials such as silver and white cloth.

# Index

### STUDIO PORTRAIT PHOTOGRAPHY OF CHILDREN AND BABIES, 3rd Ed.

*Marilyn Sholin*

Work with the youngest portrait clients to create cherished images. Includes techniques for working with kids at every developmental stage, from infant to preschooler. $34.95 list, 8.5x11, 128p, 140 color photos, order no. 1845.

MONTE ZUCKER'S
### PORTRAIT PHOTOGRAPHY HANDBOOK

Acclaimed portrait photographer Monte Zucker takes you behind the scenes and shows you how to create a "Monte Portrait." Covers techniques for both studio and location shoots. $34.95 list, 8.5x11, 128p, 200 color photos, index, order no. 1846.

### DIGITAL PHOTOGRAPHY FOR CHILDREN'S AND FAMILY PORTRAITURE, 2nd Ed.

*Kathleen Hawkins*

Learn how staying on top of advances in digital photography can boost your sales and improve your artistry and workflow. $34.95 list, 8.5x11, 128p, 195 color images, index, order no. 1847.

### LIGHTING AND POSING TECHNIQUES FOR PHOTOGRAPHING WOMEN

*Norman Phillips*

Make every female client look her very best. This book features tips from top pros and diagrams that will facilitate learning. $34.95 list, 8.5x11, 128p, 200 color images, index, order no. 1848.

### ILLUSTRATED DICTIONARY OF PHOTOGRAPHY

*Barbara A. Lynch-Johnt & Michelle Perkins*

Gain insight into camera and lighting equipment, accessories, technological advances, film and historic processes, famous photographers, artistic movements, and more with the concise descriptions in this illustrated book. $34.95 list, 8.5x11, 144p, 150 color images, index, order no. 1857.

### THE ART OF PREGNANCY PHOTOGRAPHY

*Jennifer George*

Learn the essential posing, lighting, composition, business, and marketing skills you need to create stunning pregnancy portraits your clientele can't do without! $34.95 list, 8.5x11, 128p, 150 color photos, index, order no. 1855.

### MASTER GUIDE FOR TEAM SPORTS PHOTOGRAPHY

*James Williams*

Learn how adding team sports photography to your repertoire can help you meet your financial goals. Includes technical, artistic, organizational, and business strategies. $34.95 list, 8.5x11, 128p, 120 color photos, index, order no. 1850.

### JEFF SMITH'S POSING TECHNIQUES FOR LOCATION PORTRAIT PHOTOGRAPHY

Use architectural and natural elements to support the pose, maximize the flow of the session, and create refined, artful poses for individual subjects and groups—indoors or out. $34.95 list, 8.5x11, 128p, 150 color photos, index, order no. 1851.

### CHILDREN'S PORTRAIT PHOTOGRAPHY
A PHOTOJOURNALISTIC APPROACH

*Kevin Newsome*

Learn how to capture spirited images that reflect your young subject's unique personality and developmental stage. $34.95 list, 8.5x11, 128p, 150 color images, index, order no. 1843.

### PROFESSIONAL PORTRAIT POSING
TECHNIQUES AND IMAGES
FROM MASTER PHOTOGRAPHERS

*Michelle Perkins*

Learn how master photographers pose subjects to create unforgettable images. $34.95 list, 8.5x11, 128p, 175 color images, index, order no. 2002.

# Other Books
# by Bill Hurter . . .

## PORTRAIT PHOTOGRAPHER'S HANDBOOK, 3rd Ed.

A step-by-step guide that easily leads the reader through all phases of portrait photography. This book will be an asset to experienced photographers and beginners alike. $34.95 list, 8.5x11, 128p, 175 color photos, order no. 1844.

## THE BEST OF PROFESSIONAL DIGITAL PHOTOGRAPHY

Digital imaging has a stronghold on photography. This book spotlights the methods that today's photographers use to create their best images. $34.95 list, 8.5x11, 128p, 180 color photos, 20 screen shots, index, order no. 1824.

## THE BEST OF PHOTOGRAPHIC LIGHTING
2nd Ed.

Top pros reveal the secrets behind their studio, location, and outdoor lighting strategies. Packed with tips for portraits, still lifes, and more. $34.95 list, 8.5x11, 128p, 200 color photos, index, order no. 1849.

## WEDDING PHOTOGRAPHER'S HANDBOOK

Learn to produce images with technical proficiency and superb, unbridled artistry. Includes images and insights from top industry pros. $34.95 list, 8.5x11, 128p, 180 color photos, 10 screen shots, index, order no. 1827.

## THE BEST OF WEDDING PHOTOJOURNALISM

Learn how top professionals capture these fleeting moments of laughter, tears, and romance. Features images from over twenty renowned wedding photographers. $34.95 list, 8.5x11, 128p, 150 color photos, index, order no. 1774.

## RANGEFINDER'S PROFESSIONAL PHOTOGRAPHY
*edited by Bill Hurter*

Editor Bill Hurter shares over one hundred "recipes" from *Rangefinder's* popular cookbook series, showing you how to shoot, pose, light, and edit fabulous images. $34.95 list, 8.5x11, 128p, 150 color photos, index, order no. 1828.

## THE PORTRAIT PHOTOGRAPHER'S GUIDE TO POSING

Posing can make or break an image. In this book, you will get the posing tips and techniques that have propelled the finest portrait photographers in the industry to the top. $34.95 list, 8.5x11, 128p, 200 color photos, index, order no. 1779.

## THE BEST OF PORTRAIT PHOTOGRAPHY
2nd Ed.

View outstanding images from top pros and learn how they create their masterful classic and contemporary portraits. $34.95 list, 8.5x11, 128p, 180 color photos, index, order no. 1854.

## JEFF SMITH'S LIGHTING FOR OUTDOOR AND LOCATION PORTRAIT PHOTOGRAPHY

Learn how to use light throughout the day—indoors and out—and make location portraits a highly profitable venture for your studio. $34.95 list, 8.5x11, 128p, 170 color images, index, order no. 1841.

## PROFESSIONAL CHILDREN'S PORTRAIT PHOTOGRAPHY
*Lou Jacobs Jr.*

Fifteen top photographers reveal their most successful techniques—from working with uncooperative kids, to lighting, to marketing your studio. $34.95 list, 8.5x11, 128p, 200 color photos, index, order no. 2001.

### THE PHOTOGRAPHER'S GUIDE TO
### COLOR MANAGEMENT
PROFESSIONAL TECHNIQUES
FOR CONSISTENT RESULTS

*Phil Nelson*

Learn how to keep color consistent from device to device, ensuring greater efficiency and more accurate results. $34.95 list, 8.5x11, 128p, 175 color photos, index, order no. 1838.

### CLASSIC PORTRAIT
### PHOTOGRAPHY

*William S. McIntosh*

Learn how to create portraits that stand the test of time. Master photographer Bill McIntosh discusses his best images, giving you an inside look at his timeless style. $29.95 list, 8.5x11, 128p, 100 color photos, index, order no. 1784.

### SOFTBOX LIGHTING
### TECHNIQUES
FOR PROFESSIONAL PHOTOGRAPHERS

*Stephen A. Dantzig*

Learn to use one of photography's most popular lighting devices to produce soft and flawless effects for portraits, product shots, and more. $34.95 list, 8.5x11, 128p, 260 color images, index, order no. 1839.

### WEDDING AND PORTRAIT
### PHOTOGRAPHERS'
### LEGAL HANDBOOK

*N. Phillips and C. Nudo, Esq.*

Don't leave yourself exposed! Sample forms and practical discussions help you protect yourself and your business. $29.95 list, 8.5x11, 128p, 25 sample forms, index, order no. 1796.

### MASTER'S GUIDE TO
### WEDDING PHOTOGRAPHY
CAPTURING UNFORGETTABLE MOMENTS
AND LASTING IMPRESSIONS

*Marcus Bell*

Learn to capture the unique energy and mood of each wedding and build a lifelong client relationship. $34.95 list, 8.5x11, 128p, 200 color photos, index, order no. 1832.

### PROFESSIONAL
### PORTRAIT LIGHTING
TECHNIQUES AND IMAGES
FROM MASTER PHOTOGRAPHERS

*Michelle Perkins*

Get a behind-the-scenes look at the lighting techniques employed by the world's top portrait photographers. $34.95 list, 8.5x11, 128p, 200 color photos, index, order no. 2000.

### PROFESSIONAL MARKETING &
### SELLING TECHNIQUES FOR
DIGITAL WEDDING PHOTOGRAPHERS 2nd Ed.

*Jeff Hawkins and Kathleen Hawkins*

Taking great photos isn't enough to ensure success! Become a master marketer and salesperson with these easy techniques. $34.95 list, 8.5x11, 128p, 150 color photos, index, order no. 1815.

### DIGITAL PHOTOGRAPHY
### BOOT CAMP

*Kevin Kubota*

Kevin Kubota's popular workshop is now a book! A down-and-dirty, step-by-step course in building a professional photography workflow and creating digital images that sell! $34.95 list, 8.5x11, 128p, 250 color images, index, order no. 1809.

### PHOTOGRAPHER'S GUIDE TO
### WEDDING ALBUM
### DESIGN AND SALES

*Bob Coates*

Enhance your income and creativity with these techniques from top wedding photographers. $29.95 list, 8.5x11, 128p, 150 color photos, index, order no. 1757.